IMAGES
of America

THE ROMEO
PEACH FESTIVAL

TO ANN,
ENJOY THE FESTIVAL
MEMORIES.
D. McCl_ 5/9/07.

IMAGES
of America

THE ROMEO
PEACH FESTIVAL

David McLaughlin

ARCADIA
PUBLISHING

Published by Arcadia Publishing
Charleston SC, Chicago IL, Portsmouth NH, San Francisco CA

Printed in the United States of America

Library of Congress Catalog Card Number: 2006922337

For all general information contact Arcadia Publishing at:
Telephone 843-853-2070
Fax 843-853-0044
E-mail sales@arcadiapublishing.com
For customer service and orders:
Toll-Free 1-888-313-2665

Visit us on the Internet at http://www.arcadiapublishing.com

For Ian and Eric McLaughlin

CONTENTS

ACKNOWLEDGMENTS

I must thank Tom Cox for the collection of scrapbooks and files of Katherine G. Adams, Irene Meeker, and Sara Meeker Treece. They were made available to me and provided the bulk of the photographs appearing in this book. I would also like to thank David Parks for carefully scanning all of the photographs. It allowed me to work on the research, layout, and writing of the text and his dedication is appreciated. I would also like to thank the following: Mel Bleich, *Romeo Observer,* Sue and Jerry Vagi, Tom Bishop, Albert Brough, Vera Brandt, Romeo Historical Society, Romeo District Library, Dorothy McLarty, Lois Stirling, Diane Rang, Donald Werth, Velma Jean Havers, Ed Allam and The Studio, Jennifer Gondert, Gary Corbin, Theodora Raymond, Pat Beatham, Bud Johnson, Otto Knittel, F. Gates, Frank C. Zak, Norine McLaughlin, Marian McLaughlin, Edward T. Strong, Gary Schocke, Kathy Gondert, Gen Kasuri, Bud Johnson, William Gallatin, Judy Rios, Suki Winkler, Norman York, Marguerite Hennig, ? Carlton, ? Hurley, C. J. Miller, Ora Smith, Abbie Rowe, Virginia Bjornstad, John McPartlin, John Hotz, Lee Winborn, Chuck Stringham, *Daily Leader,* Aubrey McKenzie, ? Lombardo, Jeannie Lerchen, Shelia Ruggirello, Bill Verellen, Karl and Karen Rapp, Katrina Roy Schumacher, Dave Deering, Don Kissel, Edwin Kriewall, Marv Blackett, ? Miller, Wendy Willenborg, Donna McLaughlin, Anna Robinson, Janet Albrecht, Doug Card, Gordon Dorris, Richard Cory, Judy Lopus, Ray and Ken Miller, Anne Aikman, Mildred Schmidt, Kathy Gawne, Larry Stefanski, Mary Vos, Betty Gingas, Dan Saad, Jerry Mattson, Robert Totten, Pat Rinke, Karen Conrad, and Chuck Bristol. I also extend many special thanks to my parents, Lawrence and Patricia McLaughlin.

INTRODUCTION

It is an honor for me to participate in the celebration of the 75th anniversary of the Michigan Peach Festival of Romeo, its proper name, as it is the second oldest festival in the state of Michigan.

The earliest record of raising peaches in the Romeo area is credited to Michael Bowerman. In 1813, a veteran of the War of 1812, Bowerman left his father's home in New York and fought in the Battle of Lake Erie. Given a plot of land in Detroit for his service payment, he decided instead to settle further north. Bowerman had carried a small amount of peach pits from his father's farm and ended up building a cabin and starting a farm later to become known as West View Orchards. This was just a few miles south of what was known then as Indian Village, which would later be incorporated as the village of Romeo in 1838. It was not until 1880 that Michael Bowerman's son Byron Bowerman planted 10 acres of small peach trees, giving Romeo its real commercial start.

The talk of a peach festival started with the orchard growers who had a plan that would give the orchards and the village an economic boost. They chose Labor Day weekend because of the peach harvest season. At that time, their inspiration was the Traverse City Cherry Festival that was only a few years old and was well attended. The orchard growers approached Romeo's village president Edward Jacob with the idea.

In July 1931, Jacob ventured to Traverse City with George and Marvin Faulman of Hillcrest Orchard; Edward Schuneman, manager of Eastview Orchard; and H. C. Brooks, manager of the Shepard and Brooks Farm and Stony Creek Orchards. The men studied the basics of how to begin a festival, and upon their return, Jacob formed a committee and held the first Michigan Peach Festival within a month.

The first festival, in September 1931, was a success; the coronation of the queen, the queen's ball, and the three parades brought a bit of glamour and excitement to the quiet town. It is safe to say that this event, 75 years later, has put Romeo on the map and has drawn attention to this community from throughout the state.

In the early years, the Rotary was the only service club involved, the Village of Romeo did not contribute to the festival but later set aside a fund that would help with some of the cost. The rest was the cooperation of the merchants, farmers, and orchards. In the end, everyone benefited, as their promotion brought people, and their money, into Romeo.

The festival, over the years, had some ups and downs. Over the years, interest in the event waned; the merchants trying to stay in business themselves were tired of supporting it. For three consecutive years, there were complete crop failures. There were no festivals between 1942 and 1945 during World War II.

In 1951, the Lions Club agreed to support the festival and made some changes. The original three-day event was expanded, the carnival was moved in 1956 to a field between Bailey and Denby Streets, the beer dugout held in the rear of Garrison's Chevrolet garage later became an actual beer tent, and there were new parade routes, which just ran on Main Street instead of weaving around the village.

As the years go by, the events change, but the spirit of the festival continues to attract thousands to Romeo. Here we are in 2006, surviving after all these years. Recent events like the Romeo Idol contest, the Festival of Cars at the Ford Engine Plant, and the arts and crafts show on the Croswell Elementary grounds bring in thousands of spectators on their own. Peaches still have a role to play, despite the fact that numerous orchards have been subdivided and that acres of fruit trees are now gone. There are fewer orchards in the area than what was here in 1931. The first festival guide listed 20 orchards; in the 2005 guide, only four were advertised.

I remember my first festival, it was in 1964, and we had just moved to Romeo. Driving down Main Street, I remember sitting on my knees and looking out the backseat window thinking that we were moving to the greatest place on earth. Crowds of people walking on the Main Street, a distant blur of carnival music coming from somewhere. I was quick to learn that once Labor Day passed, Romeo resumed to its laid back charm.

—David McLaughlin
March 2006

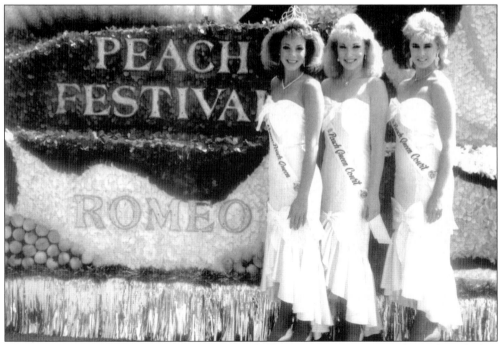

The 1986 peach queen was Kimberly Long of Shelby Township. Nicknamed "Peaches" by her friends at work, she also won the title of Miss Michigan Hemisphere and Queen of Springtime at the Home Builders Show in Detroit. Standing near the queen's float are from left to right are queen Kimberly Long and her court members Sharyln Devers and Regina Tzystuck. (Cox collection.)

One

THE 1930s

"When you want good peaches come to Romeo," stated village president Edward Jacob in the first festival program published in 1931. To start with the history of the Michigan Peach Festival, one has to start with the orchards that existed in the surrounding area years before the first mention of a Labor Day festival. In the beginning, there were thousands of acres of peaches to be picked. Driving north on Van Dyke Avenue toward Romeo in the 1930s, one would pass Verellen's, Rapp's, South View, East View, and West View Orchards. East View Farm Orchards was located at the corner of 30 Mile Road and Van Dyke Avenue. They have since paved paradise and put up a parking lot indeed. (Romeo Archive collection.)

The East View Farm Orchards was owned by Ed Strong, at that time the president of the Buick Motor Company in Flint. To the east and west of Van Dyke Avenue, the farm once covered 400 acres where they raised grain and grew fruit trees. Hidden behind the trees at 64961 Van Dyke Avenue would be the Strong home, an Italianate brick house that was converted into a bank around the early 1970s. (Romeo Archive collection.)

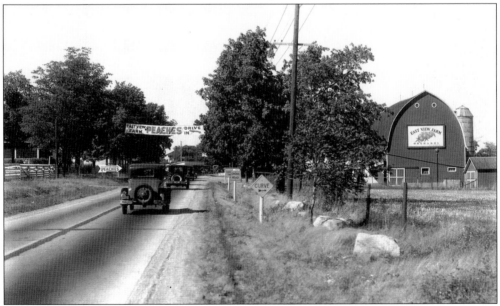

Just south of the 30 Mile Road curve is where one could pull over and purchase fresh fruit and vegetables. Here is a neat look at a row of Ford Model Ts driving on what they used to call "the Main Street of the Thumb of Michigan." Heading in the direction of Romeo for the first Labor Day weekend, this area has changed completely over time, with the west side now lined with a subdivision named Eastview Estates, a gas station, and a long trail of office buildings. (Romeo Archive collection.)

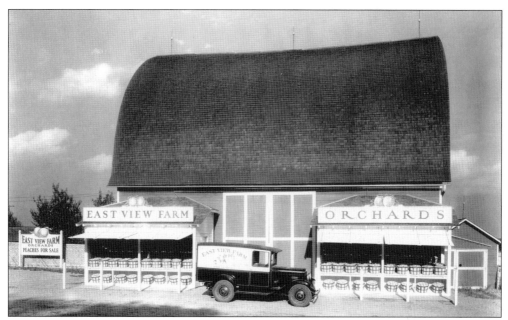

The East View produce delivery truck, a 1920s model, is parked nicely between the retail stands. In 1948, Lawrence and Catherine Rinke purchased the property and continued East View Farm. The family grew and sold potatoes until 1965. In 1977, son Pat Rinke utilized the barn as an office and storage for Blue Water Trucking until 2002, the year the barn and farmhouse were demolished. (Romeo Archive collection.)

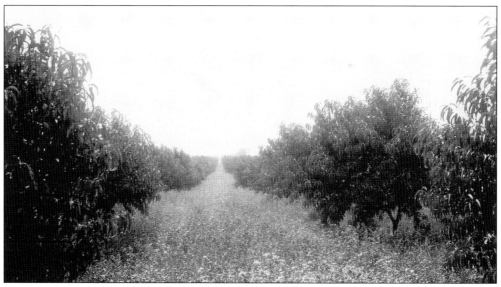

Romeo was once billed as "the Heart of Fruit Country." Here the rows of peach trees, pruned and well maintained, produce a bountiful crop. The original idea for the peach festival was suggested by H. C. Brooks, manager of the Stony Creek Orchards and a representative of the orchard growers. Brooks's committee brought the idea to village president Ed Jacob to increase sales to hold a festival and promote the peaches. The brands of fuzzy peaches included J. H. Hale, South Haven, Banner, Billmeyer, Admiral Dewey, Champion, and the Elberta was the most popular at the time. (Romeo Archive collection.)

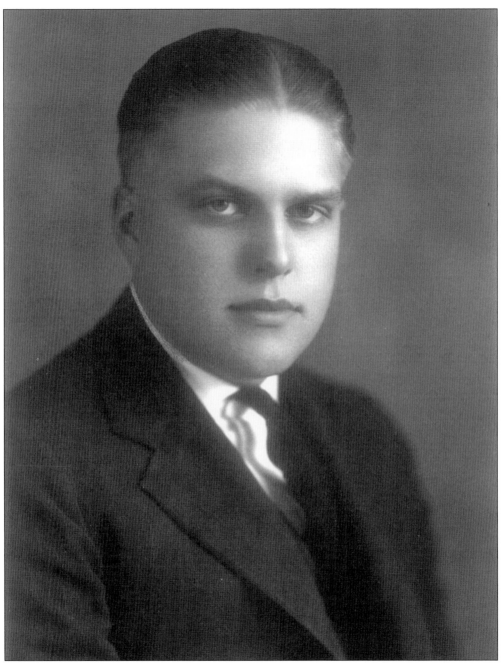

It was Romeo resident Edward A. Jacob, a local attorney and president of the village of Romeo, who traveled to the Traverse City Cherry Festival at the age of 24 and began his quest for details on how to hold a fruit festival. Once he returned, he organized a peach festival committee. It was Jacob's plan to create an interest in rural districts by creating a better understanding between farm and city life. Jacob was born on April 19, 1906, in Detroit and was a lifelong resident of Romeo. He graduated from Romeo High School, the University of Michigan, and later the Detroit College of Law. Jacob passed away on September 14, 1972, while on vacation in Tel Aviv, Israel, just weeks after being honored as the grand marshal of the 1972 Floral Parade. (Cox collection.)

Della Reckinger was chosen Miss Romeo on August 7, 1931, and then competed for the first Peach Queen Pageant the following week. The 17 year old attended Romeo High School and would graduate in 1932. She had recently moved from Detroit with her parents, Mr. and Mrs. Howard J. Reckinger, and the family had resided on East 30 Mile Road. (Cox collection.)

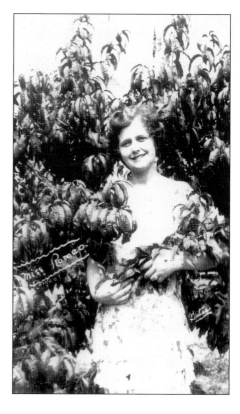

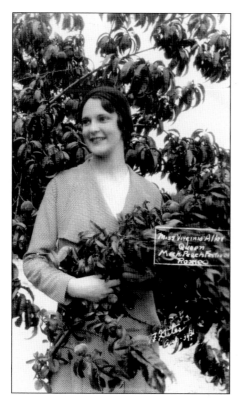

On August 15, 1931, the first Michigan Peach Queen was crowned at the Romeo High School. Virginia Allor was 18 years old and soon to be a senior at St. Mary's High School in Mount Clemens. Allor was chosen from contestants from five different counties. To become a queen, one had to compete and win in the local pageants of the counties, and then one was eligible to compete for peach queen. Allor is photographed in a local orchard on August 31, 1931. (Cox collection.)

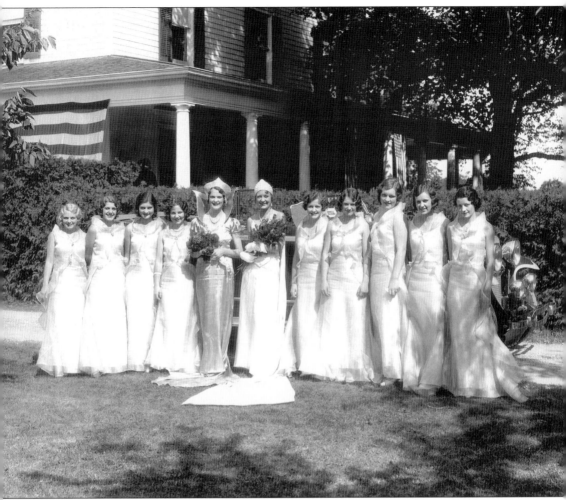

On September 6, 1931, an afternoon reception for over 200 guests was held at Paton Hall, the home of Mr. and Mrs. Parker O. Pennington at 124 West Gates Street. The Traverse City Cherry Queen, Maxine Weaver, and her parents were guests at the home for the weekend. The peach queen and her court pose for this photograph in front of a touring car. From left to right are Ann Depuis, Margaret Mallory, Edith Levely, Helen Fortin of Flint, peach queen Virginia Allor, cherry queen Maxine Weaver, Miss Romeo of 1931 Della Rickinger, Mary Fuller, Ilene Plassey, Alma Will, and Helen Landon. (Romeo Archive collection.)

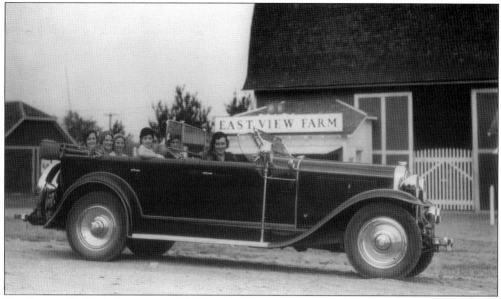

On August 31, 1931, the queen and a few of her court members went to East View for a tour of the orchard. The touring cars, possibly up to five, would make the rounds of the local orchards and sample the fresh produce. The automobile, a customized 1931 Buick Phaeton, was provided by Ed Strong. (Romeo Archive collection.)

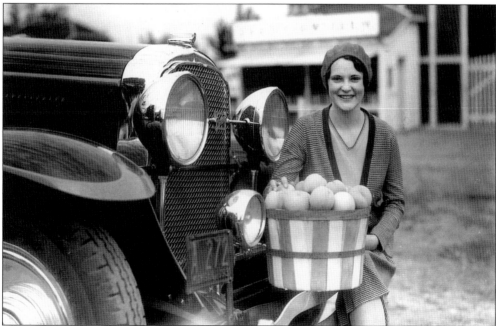

During her promotional tour as the queen, Virginia Allor had the opportunity to give peaches to President Hoover at the White House. A year later in 1932, she married Lt. Lester Krug of Monroe and after his discharge from Selfridge Field in Mount Clemens, the couple moved to Akron, Ohio. On a flight from Cleveland to Akron, which was piloted by Krug, the plane flew into an unexpected snowstorm and hit a tree. The first peach queen, along with her husband, was tragically killed at the age of 20 in April 1933. (Romeo Archive collection.)

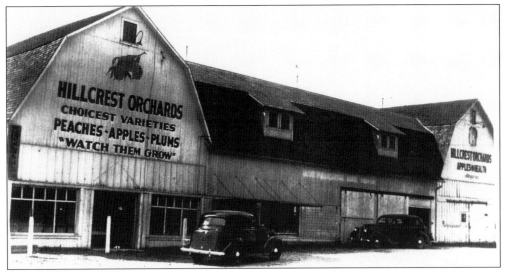

G. W. Faulman of Detroit came to Romeo in 1923 and established the Hillcrest Orchards, planting 40 acres and increasing it to nearly 200 by the 1930s. It was located half a mile west of Romeo on the south side of 32 Mile Road. It grew only fruit; the popular apples, peaches, pears, and plums. In the 1950s, it was sold to a developer and later became a subdivision named Applewood Valley, with the streets Orchard View, Apple Orchard Way, and Apple View replacing the acres of fruit trees. (Romeo Historical Society collection.)

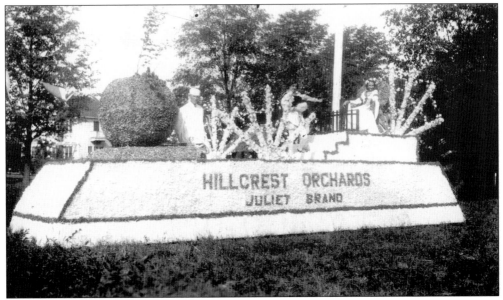

The first Floral Parade consisted of about 30 entries and had an unusual route, starting at Tillson Street to North Main Street, west on Gates Street, then to Prospect Street, to West St. Clair Street heading east, and ending at Railroad Street. In the first parade, the Hillcrest Orchards float won second place. The float was decorated in white and gold, and in front of the large peach, the girls Ruth Ernsberger and Jane Van Buskirk acted out the balcony scene from the play Romeo and Juliet, advertising of course the Juliet brand of peaches. (Cox collection.)

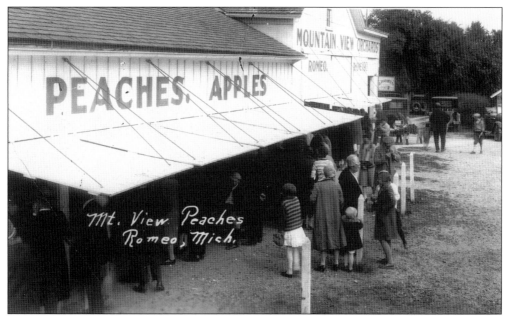

Albert Griggs came to Romeo in 1916 and opened Mountain View Orchards, planting 160 acres of peaches. With the help of his son Perry, they planted another 110 acres in the 1930s. The orchard was located on West 32 Mile Road past the cemetery. At one time, Smith Reed and later Lee Barrows managed the orchard. After Barrows's death, his wife sold 140 acres, closing the orchard around 1948. The property later became the site of the second Romeo High School in 1958. (Lopus collection.)

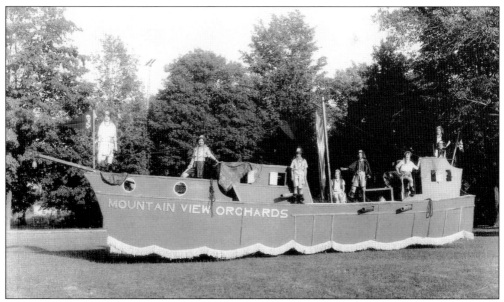

Mountain View Orchard entered a large pirate ship complete with a skull and cross bones mast into the 1931 Floral Parade. The float was big enough to hold eight scalawags and in no particular order they were Helen Elizabeth, Eleanor Griggs, Phyllis Griggs, Jeanette Gass, Barbara Carl, Kathryn Kegler, and Patricia Ann Ostrander. (Romeo Historical Society collection.)

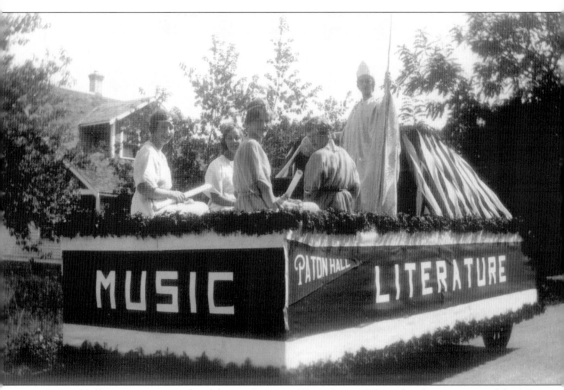

Paton Hall was a private school located at 124 West Gates. The school was operated by Mr. and Mrs. Parker O. Pennington, who opened it in 1927. In the mid-1930s, it was known as the Pennington School for Girls. This float was decorated in green and white, representing the colors of the school. Mary Stone is dressed as Minerva, the Roman goddess of wisdom, with her Grecian robe draped over her. Around her were disciples of learning holding their diplomas, in no particular order are Martha Greenshields, Barbara Stone, Muriel Rumsey, and Helen Kegler in robes of orchid, pink, and green. The float is parked near 70060 Mellen Street, waiting to join the Floral Parade. (Romeo Historical Society collection.)

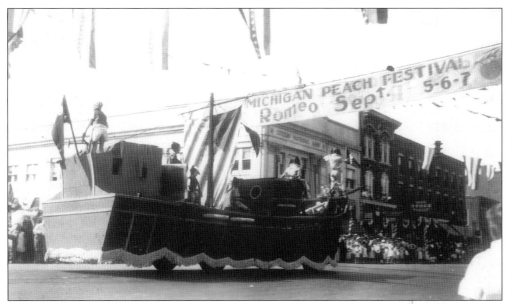

This view shows the 1931 Floral Parade as it passes the center of town underneath the Michigan Peach Festival banner. The pirates tossed peaches from a realistic treasure chest to the crowd that lined the streets. The hard work in building a memorable float paid off as the orchard won the third-place prize. (Cox collection.)

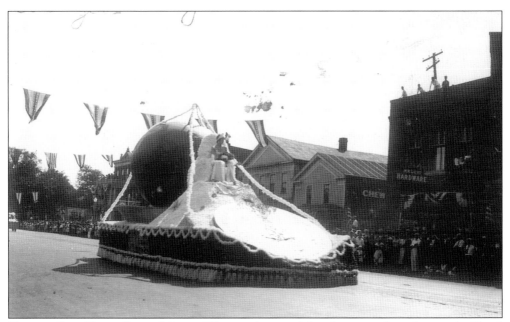

Traverse City Cherry Queen Maxine Weaver, along with her float, won first place in the Floral Parade. The queen sat on a throne in front of a large cherry pie with a large red cherry placed on top. The float is passing in front of the L. L. Licht Hardware store at 112 South Main Street. (Cox collection.)

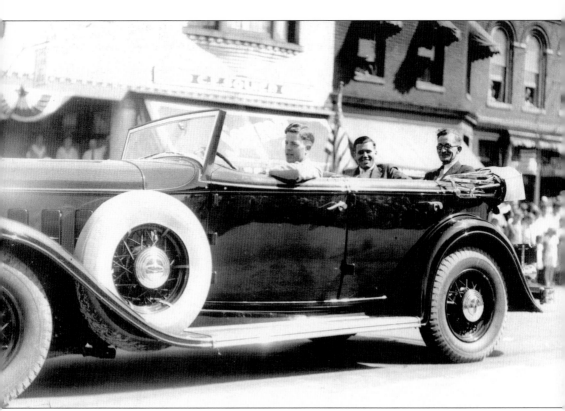

In the 1932 Floral Parade, attorney Edward Jacob, still Romeo's president and also the peach festival general chairman, made an appearance in the parade. Riding along to the right is William Bailey, the vice chairman of the festival. The young man in the driver's seat chauffeured the loaned automobile from Detroit. (Cox collection.)

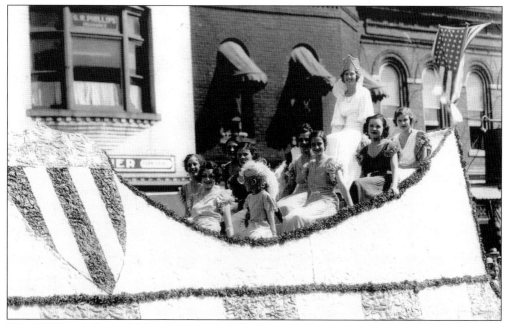

The 1932 Peach Queen Helen Cheesman of Clarkston and her court appear in the Floral Parade. The queen also met and presented President Hoover with a basket of peaches. Mary Stone, Miss Romeo of 1932, sits third from the left with Madeline Reed of Dryden on the far right. The others, in no particular order, are Marie Starckel of Flint, Shirley Gleason of Genesee, Amber Penny of Pontiac, Phyllis Hagen of Macomb, Ruth Donaldson of Lapeer, Ruth Steffens of Mount Clemens, and an unidentified child in costume. (Cox collection.)

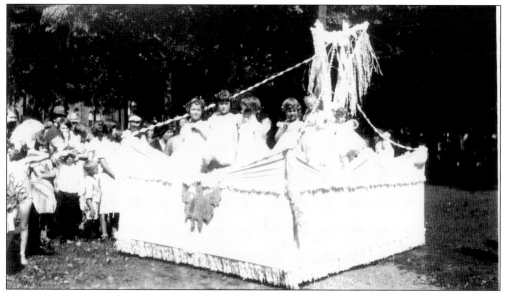

An entry for the 1932 Juvenile Parade is parked on the lawn of North Grade Elementary on North Main Street. The six little girls are unidentified, but their float is getting some attention from the crowd. The children's parade always preceded the Floral Parade. It would begin at Hollister Street and travel south on Main Street to Lafayette Road, and then return back to Hollister Street using both lanes, giving the crowd a closer view of the pint-sized floats. (Cox collection.)

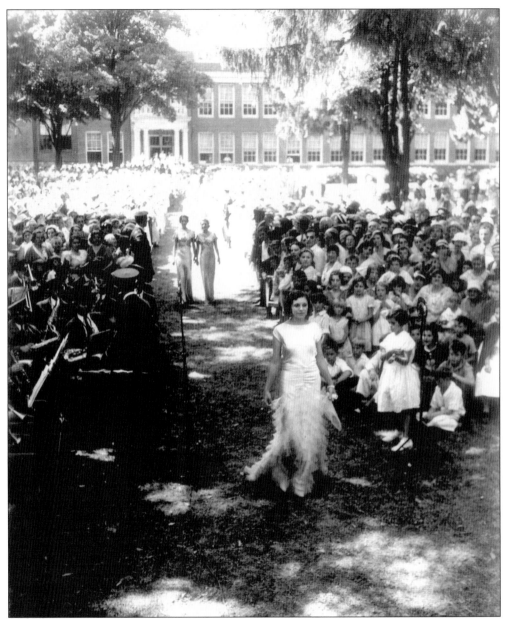

Shown here is a view of the 1933 coronation ceremony held on Labor Day at the Romeo High School front lawn on Prospect Street. The noon ceremony was broadcast live during the National Farm and Home Hour. Master of Ceremony Bob Brown introduced Ed Jacob, who gave a short speech about the orchards of Romeo. Then the American Legion Band from Utica, under the direction of McArthur, played "Show Boat." Jesse P. Wolcott, U.S. Representative of the 7th District, was introduced and spoke to the audience about how it was a pleasure to crown the third peach queen. At that time, two children, Sally Robertson and Donald Chubb Jr., started the procession from the school steps. Following was the peach queen, Lucille Plassey of Rochester, who made her way to the silver thrown on the platform. Then the queen's maids of honor, Arlene Reynolds of Romeo and Marie Callahan of Flint, followed behind, as shown above in this photograph. (Cox collection.)

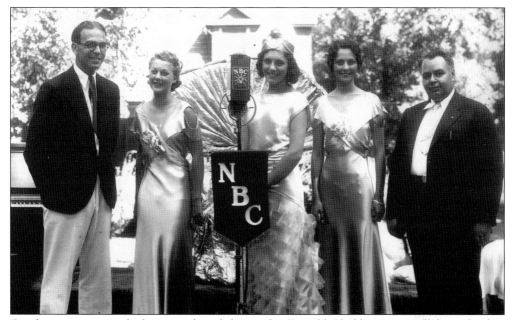

On the announcer's platform are, from left to right, Donald Chubb; Marie Callahan, the first maid of honor; queen Lucille Plassey; Arlene Reynolds, Miss Romeo of 1933, and also the second maid of honor; and Jesse P. Wolcott. Following speeches by both Jacob and Wolcott, the queen and her court spoke to the radio audience briefly. (Cox collection.)

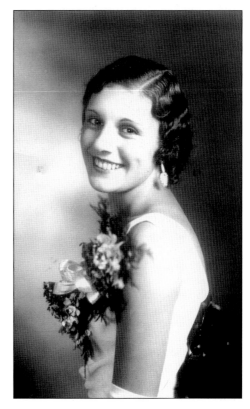

Being able to promote the festival was a big requirement for the young girls. Queen Lucille Plassy, then 17 years old, attended the Century of Progress World's Fair in Chicago and then flew to Washington, D.C., to deliver a peach pie to the White House, quite a bit of excitement for someone who had never left home and had never been in an airplane. (Cox collection.)

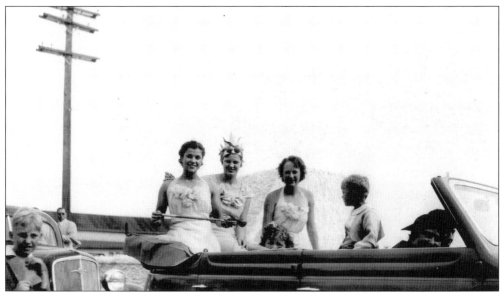

The girls are taking a break in the car before the 1934 Floral Parade. From left to right are Erma Little of Flint, the first maid of honor; peach queen Marion Lapish of Port Huron; Phyllis Miller of Walled Lake, the second maid of honor; Jack Schaff; and queen's chaperone, Harriet Borland, in the passenger seat. That is Shirley Levine peeking over the back seat door. (Cox collection.)

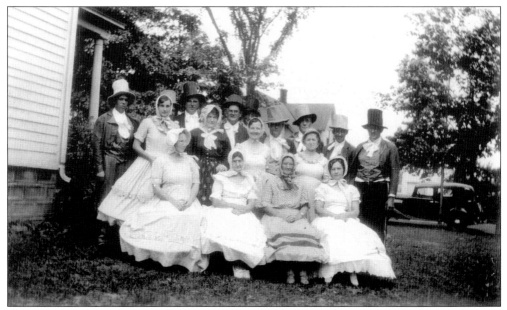

A group of friends pose at the Kohlhagen home at 155 Church Street in early 1930s just after a festival program at the high school. From left to right are (front row) unidentified, Minnie Stepnitz, Mary Werderman, and Edith Kohlagen; (second row) unidentified, Josephine Scheuneman, and two unidentified women; (third row) two unidentified men, Hugh Stepnitz, unidentified, Harry Kohlhagen, unidentified, and Art Werderman. (McLarty collection.)

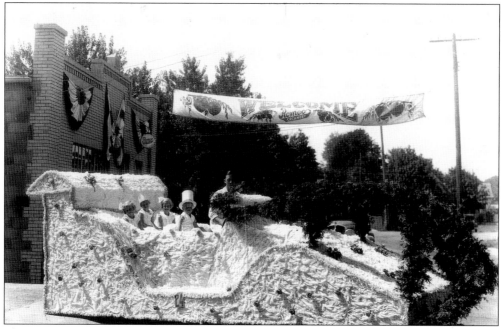

The Romeo Creamery float is parked in front of the business at 119 West Lafayette Street. On the float from left to right are Janet Nott, Mary Nott, Janice Nott, Steven "Jack" Nott, the children of Russell and Perry Nott; driving the float is Gordon E. Roberson. Even after having a flat tire during the parade route, they actually won second place in the 1933 parade. This brick building, known as the Ira Wilson building, was built in 1930 and was later destroyed by a fire in the early 1950s. (Romeo Historical Society collection.)

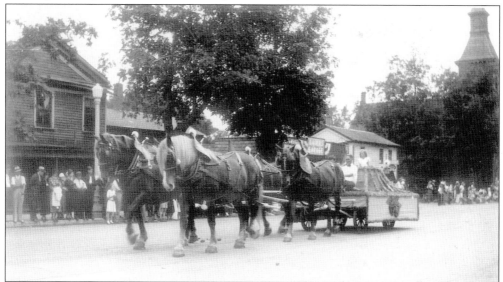

The Brookwood Orchards float is pulled by a team of Belgian horses near the corner of East Lafayette and South Main Streets. The orchard was located six miles north of Romeo near Almont, and its float entry from the Bristol family actually won third place in 1934. Behind is a view of the southeast block of buildings that once lined the street. The Bauer's Garage building at 149 South Main Street still stands. (Cox collection.)

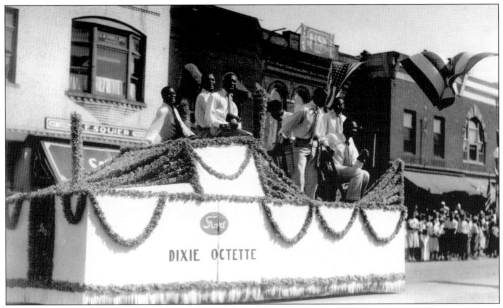

The Dixie Octette was a professional vocal group that was a gift from Henry Ford in 1934 and represented Lane's Ford dealership located on South Main Street. Note the Ford emblem on the side of the float. The singing group was based in Detroit and also performed in the center of town during the free entertainment acts segment. Other musical performers that year were The Mountaineers and Jimmy Dicco with his famous 10-piece band. (Cox collection.)

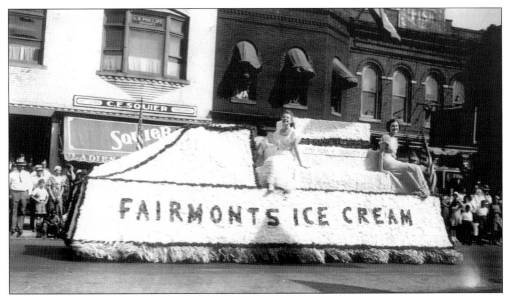

In 1934, the Fairmont Ice Cream float was decorated with a large brick of ice cream. The passengers included Pauline Ewalt (left) and Julianna Bedell (right), passing the southeast block of Main Street. Behind the float is C.F. Squire, a ladies apparel and fabric store, at 103 South Main Street. (Cox collection.)

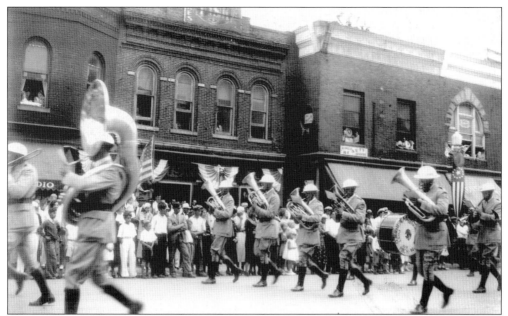

In 1934, the Romeo American Legion Band was in full swing passing 107 and 109 South Main Street. Every parade needs a marching band, and this had more than one. The building on the far right, 113 South Main Street, is shown in its original state prior to the south side being lowered to a one-story building after a fire. (Cox collection.)

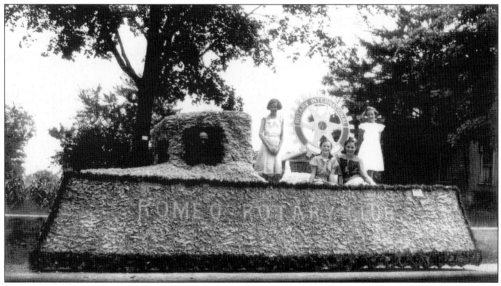

In 1934, the Romeo Rotary Club entered a float in the Floral Parade. The Rotary was charted in 1928, comprised of business and other professionals in the village. It has become one of the oldest service clubs in Romeo. The organization helped with the construction of the high school's Memorial Field. The float is parked near 245 Pleasant Street. (Cox collection.)

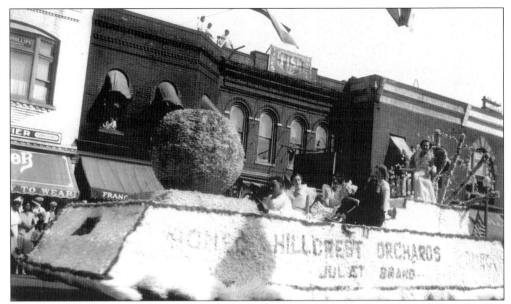

In 1934, the Hillcrest Orchards float advertised the Juliet brand of peaches, a beautiful float with a large peach at the front and a group of young ladies at the back. On the throne is Marion Rumsey and the girls, in no particular order, are Helen Gray, Kathryn Rowley, Muriel Rumsey, and Barbara Stone. (Cox collection.)

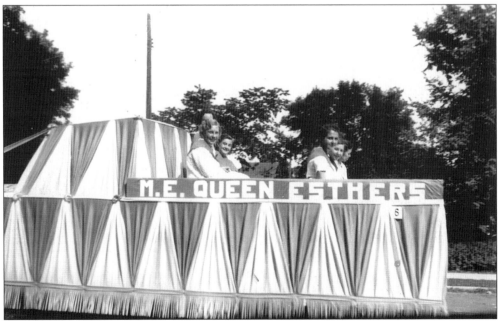

The M. E. Queen Esthers entered a float in the 1935 parade. The guild represented the Methodist Episcopal church; from left to right are (first row) Agnes Schoff and Joan Eldred; (second row) Irene Morte (who is slightly hidden) and Edna Blohm; (third row) Virginia Emmons and Lena Randall. (Cox collection.)

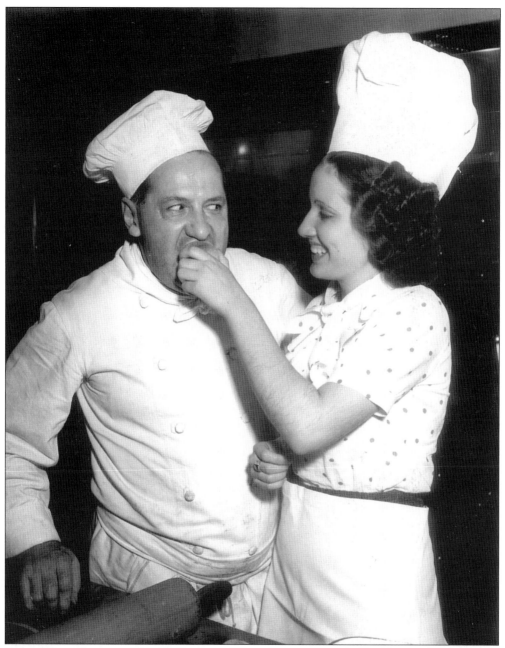

The 1936 peach queen, Mozelle Cravens of Flint, hams it up with Chef Risser of the Chicago Merchandise Mart. The chef samples a Romeo peach from the hand of Cravens during a promotional visit to Chicago. She was accompanied by Ed Jacob and her court. While in the windy city, Cravens spoke on the radio during the National Farm and Home Hour. Prior to Chicago, she traveled to Washington, D.C., to leave a basket of peaches for President Roosevelt. The queen also traveled to Cleveland for the Great Lakes Exposition. (Cox collection.)

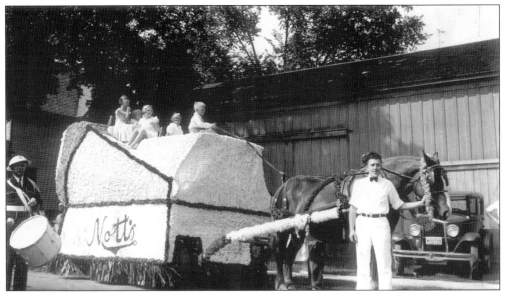

Reliable employee Marshall Lock steadies the horse, as the Nott's Romeo Creamery float gets ready to join the 1936 Floral Parade. With the Nott children sitting on top, it is an important job. The stable was located behind the building at 119 West Lafayette Street. (Cox collection.)

In 1936, there was a reunion of the former Miss Romeos. There were only five at that time. In no particular order, Della Rickinger (1931), Mary Stone (1932), Arlene Reynolds (1933), Beulah Downs (1934), and Kathryn Hipp (1935) smile and wave at the crowd. The parade is passing 208 Church Street at the corner of Prospect Street en route to the high school grounds. (Cox collection.)

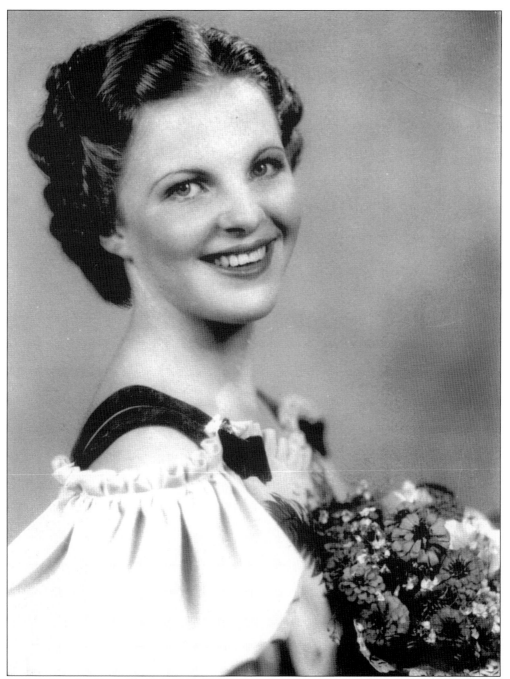

In 1937, Lois Beal became the first Romeo girl to win the peach queen title. Only 16 years old at the time, Beal worked both as a clerk at the D&C store and a cashier at the Juliet movie theatre. In the two weeks prior to the Labor Day weekend, she went on a publicity tour, traveling to Chicago to speak on the National Farm and Home Hour radio program. From there she flew to Washington, D.C., to present peaches to a representative of President Roosevelt. When she arrived back to Romeo, Mayor Charles W. Ellsworth presented the queen the key to the village. (Cox collection.)

An interesting look at the parade at the corner of Benjamin and South Main Streets was photographed here from the window of the First Baptist Church. The parade route actually began at Pleasant Street and snaked its way through the village ending at Prospect Street. (Bishop collection.)

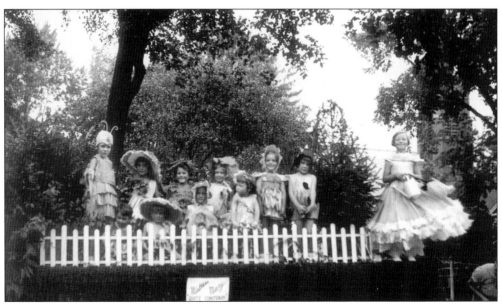

The Mistress Mary Quite Contrary float won third place in the 1937 Juvenile Parade. On the right is Mary with her watering can, and in the garden there are nine children dressed like flowers and a bug. The theme for the parade that year was nursery rhymes. They are in the village park with the Congregational church steeple behind. (Cox collection.)

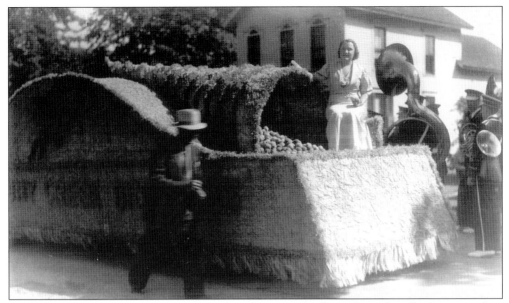

This Stony Creek Orchards float appeared in the 1937 Floral Parade. Riding the Runaway float is Beverly Beers. The man running along side could be the driver. The orchard, which opened around the 1920s, was located on 32 Mile Road and was then managed by H. C. Brooks. In 1939, Henry Ross and son Lorne moved from Rochester and purchased the property. After Henry's death, Lorne and his son Roger Ross resumed in 1970. Currently Roger and Carol Ross, along with Lorne's wife, Ruth, operate the orchard renamed Stony Creek Orchard and Cider Mill. (Cox collection.)

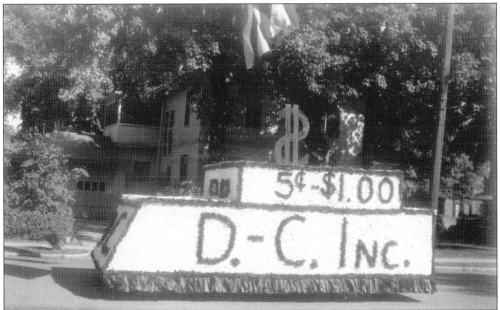

The D&C store even entered a float in the 1937 Floral Parade. The dime store was owned by George Tish and was located at 205 North Main Street until 1974. Any kid's allowance, be it 5¢ or $1, could buy either candy or toys. The simple float is passing 208 Church Street near the corner of Prospect Street. (Cox collection.)

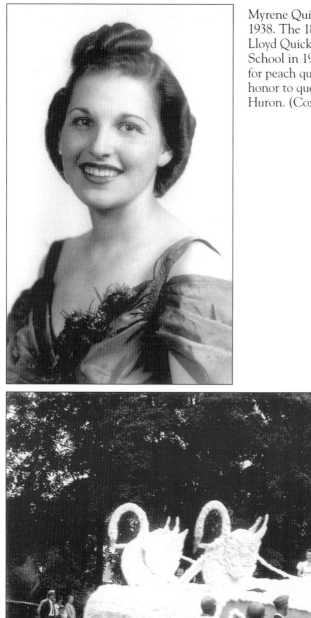

Myrene Quick was crowned Miss Romeo of 1938. The 18-year-old daughter of Mr. and Mrs. Lloyd Quick had graduated from Romeo High School in 1937. A few weeks later, she competed for peach queen and placed second maid of honor to queen Frances Leithauser of Port Huron. (Cox collection.)

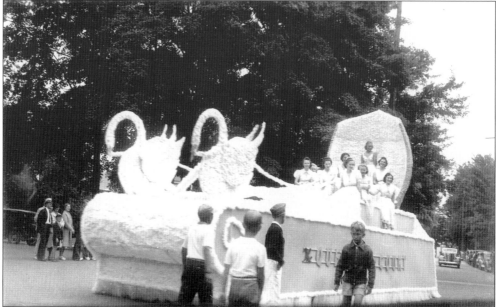

In the 1938 Floral Parade, all nine members of the court rode a decorated dove sleigh. It was an impressive float. Peach queen Frances Leithauser is on the throne, and to her right is Myrene Quick, the second maid of honor. The queen and her chaperone traveled to Washington, D.C., to present President Roosevelt with peaches and then off to New York and Chicago, where Leithauser appeared on two radio shows to promote the festival. (Cox collection.)

In 1939, Nancy Barber was the second girl from Romeo to win the peach queen title. The 17 year old was the daughter of Bertha Barber and a 1939 graduate of Romeo High School. She traveled to Washington, D.C., to leave two baskets of peaches at the White House for President Roosevelt. She met his secretary Gen. Edwin W. Watson instead. She also traveled to Chicago and New York along with Ed Jacob and the queen's chaperone, Eva Robertson. (Cox collection.)

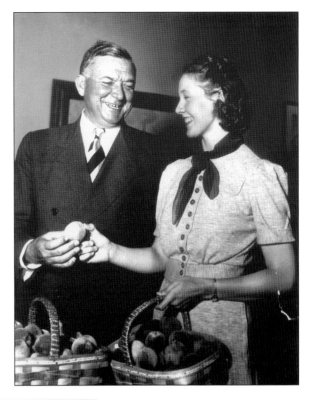

Peach queen Nancy Barber met with Detroit mayor Richard Reading at the city hall, giving him two baskets of peaches. The queen also met with Michigan governor Luren D. Dickinson in Lansing. On her trip to Chicago, she attended the College All-Star and New York Giants Football game at Soldiers Field and met Johnny Pingel, Michigan State half back of Mount Clemens, and Elmer Layden, the All-Star coach, presenting peaches to both before the game. (Cox collection.)

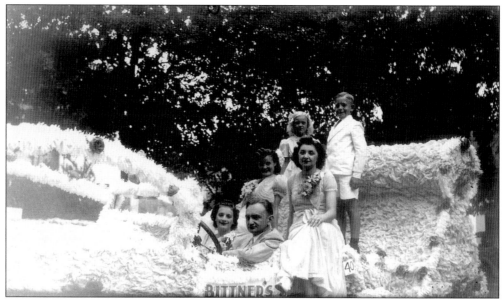

The Bittner's Bakery float won first prize in 1939. The popular village bakery, well known for its cakes and doughnuts, was located on North Main Street. Otto Bittner and his wife and two children are photographed with their white frosted float. (Cox collection.)

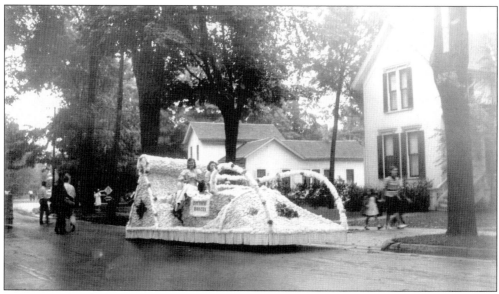

Here is another look at the winning Bittner's Bakery float as it glides past 460 and 450 North Main Street near the Gates Street curve. The busy bakery was in business until about 1951. (Cox collection.)

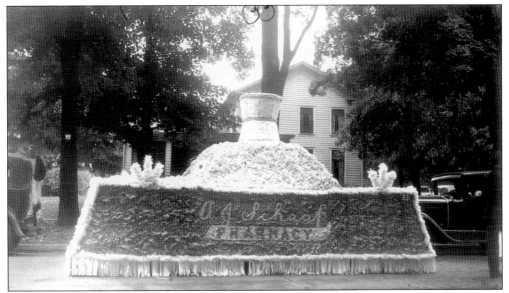

The local merchants who supported the festival also got involved in the parades, as most of the businesses entered floats. The A. J. Schaff Pharmacy float received honorable mention in the 1939 parade. Schaff's drug store was located perfectly at the four corners at 101 South Main Street. The float is passing in front of 428 North Main Street. (Cox collection.)

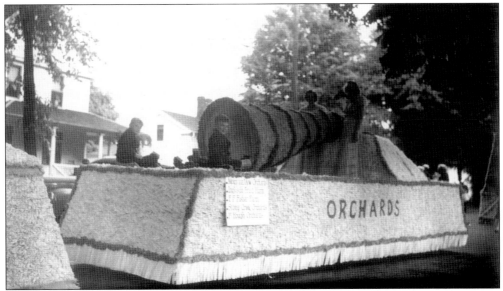

The orchards float represented a number of orchards and farms in the surrounding area. Those listed on the attached sign are Mountain View Orchard, Ingleside Fruit Farm, E. F. Fisher Farm, Stony Creek Orchard, and F. Hough Orchards. The unidentified children are possible family members that are riding along. (Cox collection.)

Former peach queen Lois Beal made a return visit at the 1939 Floral Parade. Having been the first girl from Romeo to become queen in 1937, she was invited back for another appearance in the parade. The float is passing 115 North Main Street near Starkweather Alley. The second-floor window sign reads, "Honolulu Conservatory of Music. Hawaiian and Spanish Guitar." (Raymond collection.)

Two

THE 1940S

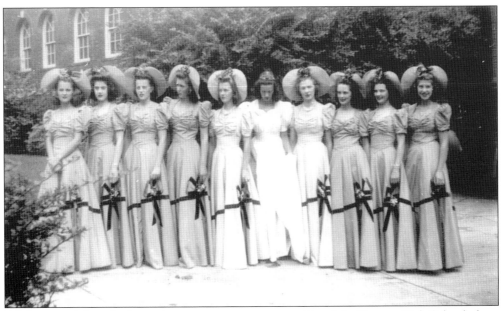

Peach queen Mary Carlton takes a moment to pose outside of the Romeo High School along with her court. The school was the location for most of the early coronation ceremonies, pageants, and dances. The queen's promotional tour in 1940 consisted of meeting with Detroit mayor Richard Reading, catching a Tiger baseball game, and going to Washington, D.C., to give a basket of peaches to President Roosevelt, but having to leave them in the hands of a White House receptionist. (Cox collection.)

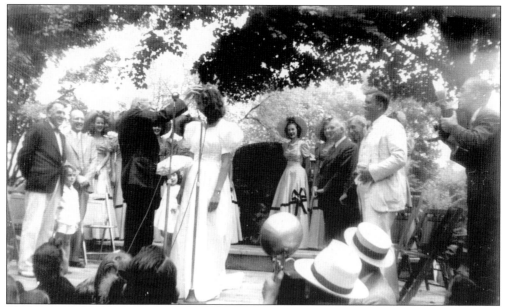

The 1940 peach queen was Mary Carlton of St. Clair, shown here being crowned by the village president. Among the few people who can be identified is (third from left) court member Donna Massie of Lapeer, and the man sporting the white suit coat is Donald Chubb, a peach festival committee member. (Cox collection.)

In 1940, the winner of the Miss Romeo pageant was Maxine Ganfield. The 18 year old was the daughter of Roxy Ganfield, who graduated from Romeo High School in 1940. At the time of the pageant, she was a cashier at the Juliet Theatre. Other contestants that year were runner up Belva Boerema, Carmelia Mellie, Jean Short, and Charlotte Fleming. (Cox collection.)

During the festival weekend, there would be free acts that would perform near the four corners on a bandstand. The show would feature talent from vocal groups, solo acts, dancers, or comedians. Earl and Oscar got the crowd roaring in laughter with their brand of sarcastic humor. Oscar Geatherb performed a private show in the Miller Insurance office as they sponsored his appearance in 1941. (Raymond collection.)

Miss Romeo of 1941 was Arlene See, the 16-year-old daughter of Mr. and Mrs. Herman See, who lived at 454 North Bailey Street. Arlene also entered and lost the Traverse City Cherry Festival pageant earlier that summer. She was a sophomore at the Romeo High School and was a member of the chorus and a drum majorette. (Cox collection.)

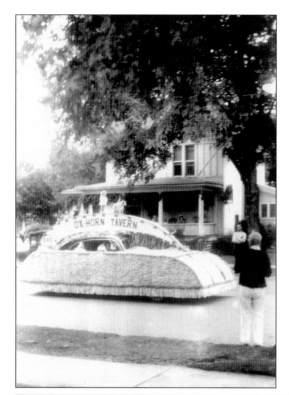

The parade routes were not always confined to just Main Street. For example, at this time, the route is as follows: begin at the corner of Minot and North Main Streets, to South Main and Pleasant Streets, to Cook Street, to Benjamin Street, go east to Rawles Street, to West St. Clair Street, to Prospect Street, to Church Street, to North Main Street where it ends. The Oxhorn Tavern float is gliding past 137 West St. Clair Street in the 1941 parade. There is a brave toddler and a pooch on the top of the car. Better stand still. (Stirling collection.)

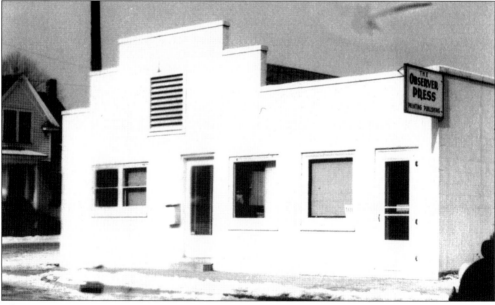

This is the Romeo Observer building at 124 West St. Clair Street. The *Romeo Observer*, which has been published since 1866, has featured front-page highlights, festival programs, and orchard information since 1931. The former publishers over the last 75 years have included Merton "Timmy" Smith, who retired in 1936; C. E. Marentette; Harry Hathaway; Alyce and Leo Larson; William J. Eva and C. E. Howard Jr.; and Mel and Joan Bleich, who bought the award-winning local newspaper in 1959. (Werderman collection.)

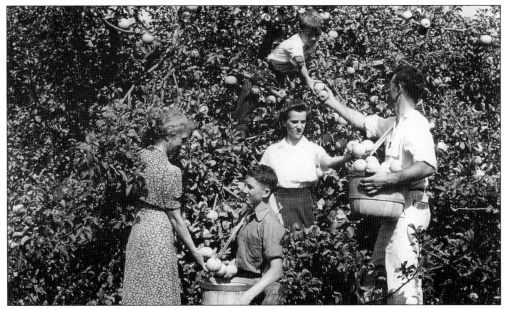

Working together was the family way at the Brookwood Fruit Farm north of Romeo. In the fields around 1942 are, from left to right, mother Annie Bristol, William J. Bristol, Margaret Bristol, Robert Bristol on a ladder, and father William K. Bristol holding the basket of peaches. William K. Bristol opened Brookwood Fruit Farm in 1923 on Bordman Road in Almont. His son, William J. Bristol, had five children and his son Charles Bristol and family have been operating the orchard since 1975. (Bristol collection.)

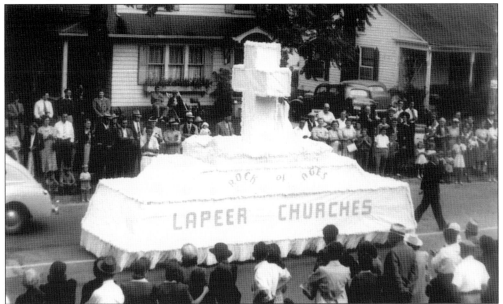

In 1941, the stark white Lapeer Churches float represented all of the congregations in the Lapeer area. Combining forces were the Liberty Street Gospel, the Presbyterian, the Methodist, the Evangelical Lutheran, the Episcopal, and the Catholic church. The float, by the grace of God, won the grand prize in the Lapeer Day parade. A few weeks later in Romeo, the same float won first prize in the Floral Parade. (Bishop collection.)

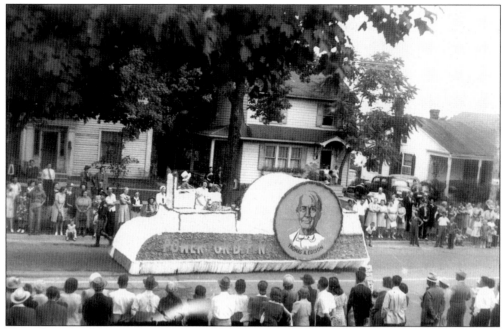

The Thomas Edison float represented the Edison office on Main Street that was in business until the late 1960s. The float with Edison's image is in remembrance of the Michigan inventor who passed away in 1931. The float is passing in front of homes at 231, 235, and 239 South Main Street. (Bishop collection.)

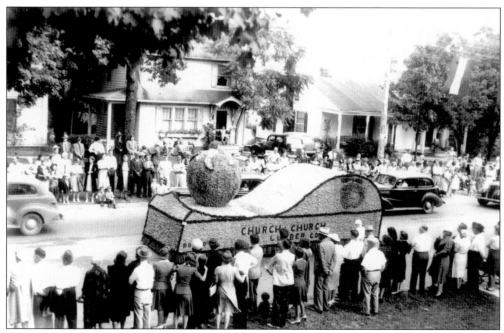

Church and Church Lumber entered a float the same year. The hardware and lumberyard was located East St. Clair Street near the former railroad tracks. Albert Brough, who lived at 226 South Main Street across the street, took these photographs. (Bishop collection.)

At the end of the 1941 parade, it was time to go home. The crowd walks the lonely Main Street path. The peach festival on Labor Day weekend has become like a parting shot of summer. The fall is coming, and soon it will snow. Little did the public know that it would be the last festival for four years, due to World War II. The festival would not resume until 1946. (Bishop collection.)

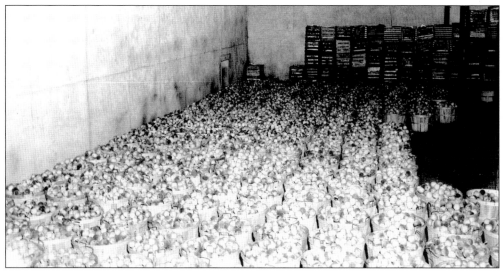

Romeo Orchards was located on Van Dyke Avenue between West Gates Street and 33 Mile Road. It opened around 1918 as the Heights Valley Company and had approximately 26,000 apple and peach trees. Years later, D. Oliver of Pontiac bought the 260-acre orchard and changed the name to Romeo Orchards. Joseph Vallie managed the orchard. The orchard sold wholesale to the Detroit Eastern Market. Shown here in the storage building are bushel baskets of peaches ready for delivery. The property became residential by the late 1950s. Replacing the fruit trees are street signs with fruit names, Morency, Dutchess, Johnathan, Wealthy Lane, and Romeo Orchard. (Werderman collection.)

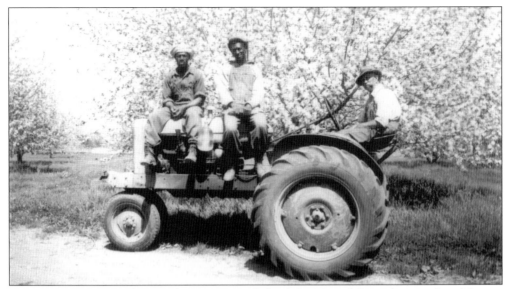

During World War II, the British government helped the United States by providing labor to the orchards and farms. Volunteer help came from the British West Indies via primarily Jamaica and Barbados. There were about 1,500 Jamaican men that traveled over in a troop ship from Kingston to Louisiana. The Southeastern Michigan Growers Association was in charge of getting help for the area orchards. The men were provided with medical coverage, food, and lodging and attended educational meetings on their job requirements. A few found their way to Westview Orchards to harvest fruit and vegetables. At the orchard, Armand Bowerman poses with Roe and Woody, two of the hired hands. (West View collection.)

At Mountain View Orchards during the harvest season they had as many as 300 workers in the fields. From left to right are Alexander Ferguson, Aubrey McKenzie, Bill White, and manager Lee Barrows. The men are working on a caterpillar, a large spray rig that mixes pesticides and water to be sprayed on the trees to manage insect damage. (McKenzie collection.)

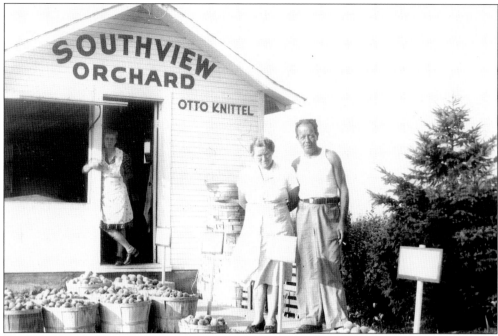

Southview Orchard owner Otto Knittel Sr. stands next to his produce stand with his peaches ripe for the selling. From left to right in the doorway are ? Riemann, Fanny Knittel, and Otto Knittel Sr. photographed here in 1946. The Southview Orchard was located on the east side of Van Dyke Avenue between 29 and 30 Mile Roads. The Knittels purchased the property in 1933 and planted the rows of fruit trees. Otto Knittel Jr. took over the farm and orchard in 1953. He continued to grow peaches, apples, pears, and plums. (Knittel collection.)

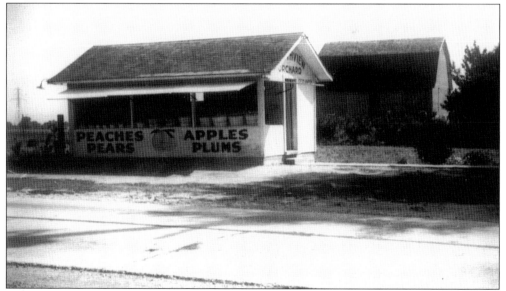

The original Southview Orchard retail stand stood on the east side of Van Dyke Avenue between 29 and 30 Mile Roads. It was moved back in 1951, and a larger brick building was built on the original location. The Knittel's last crop was in 1997, and the Southview farm was sold in 1998. (Knittel collection.)

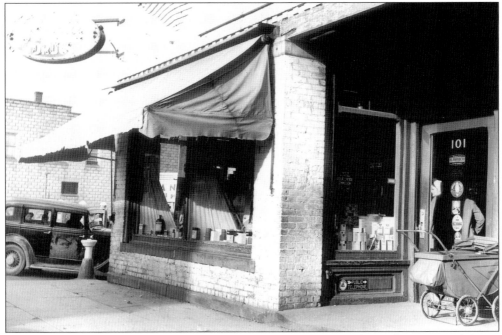

Downtown Romeo seemed quiet during the war. Schaff's Pharmacy, located at 101 South Main Street, had seen busier days. This is a view of the storefront around 1945, with a neon Rexell Drugs sign. These photographs of the drug store were taken by Donald Werth, a Romeo freelance photographer. (Werderman collection.)

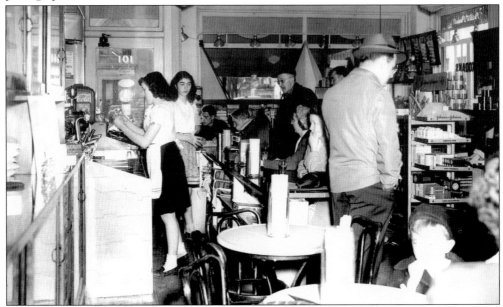

Inside working hard behind the soda counter are teenage soda jerks Barb Sanday (left) and Suzanne Chubb. The drug store was operated by Al Shaff and his son Jack, who were both pharmacists. After Schaff's, the drug store was sold to Dick Morley from Rochester, who opened Morley's Drugs around 1965. The building finally ended its corner drug store history around 1981. (Werderman collection.)

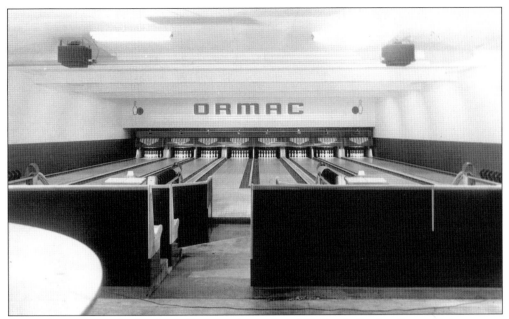

Ormac Recreation, the bowling alley, was located at 122 South Rawles Street and was very popular with families during the 1940s up through the 1960s. The art modern structure was built in the 1930s and was renamed the Village Lanes in 1965. The building later became the Blue Banjo Lounge in 1976, with rare appearances by Chubby Checker, Freddy Cannon, Mitch Ryder, and Tommy James. It is currently an office building. (Werderman collection.)

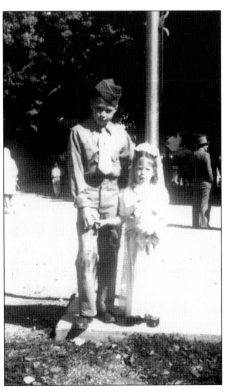

After the war ended, the peach festival resumed in 1946. The young children, Neil Gray and Anne Knight, are in costume as a solider and bride. The cousins are standing at the base of the flagpole at the North Grade Elementary School. The name Juvenile Parade was changed to the Children's Parade in 1946. (Cox collection.)

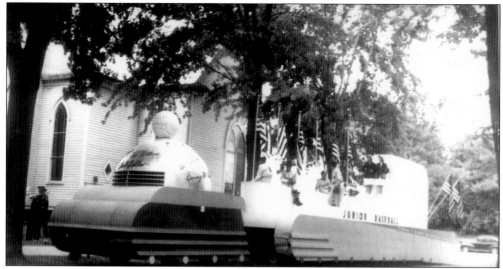

The Ford Motor Company's 90-foot junior baseball float was sponsored by Cool Motor Sales. It was the longest of all floats in the 1946 Floral Parade. The futuristic looking float is parked on Benjamin Street near the Lutheran church. It featured on the helmet team names paired with an oversized baseball. (Bishop collection.)

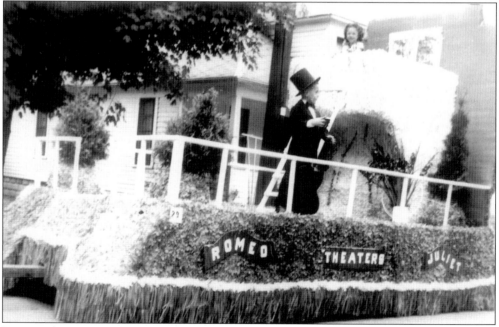

Romeo's theater contribution was the Romeo and Juliet float shown in front of 109 Cook Street during the parade in 1946. The Juliet Theatre was originally known as the Palace Theatre before closing in the late 1940s. The Romeo Theatre, located just a block south down the street, closed in 1967. (Bishop collection.)

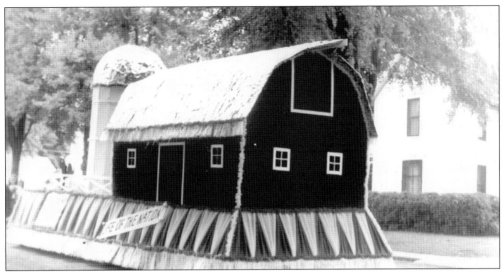

The Interlocking Cement Stave Silo Company of Romeo and Imlay City won third place in the Floral Parade, with a large float featuring a large barn and silo decorated with floral trimmings. Gideon Sieweke owned the company on south Sisson Street until the early 1960s. It housed a lumberyard and cement blocks used for building silos. The sign attached to the side reads, "Life of the Nation," as it once was. The Sisson Park condominiums are now on that site. (Bishop collection.)

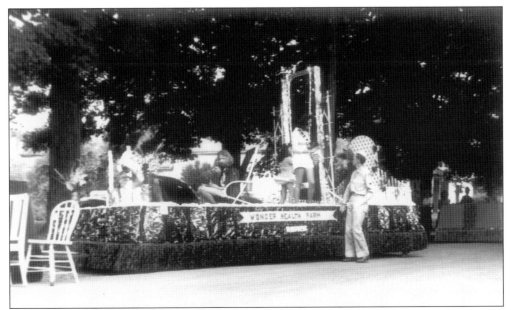

The Wonder Health Farm even entered a float in the 1946 Floral Parade. The spa for rest and relaxation was located for a short time at the former Ransom B. Moore house at 439 Prospect Street. Actress Mary Martin visited the spa while performing for a week at a Mount Clemens theater. (Bishop collection.)

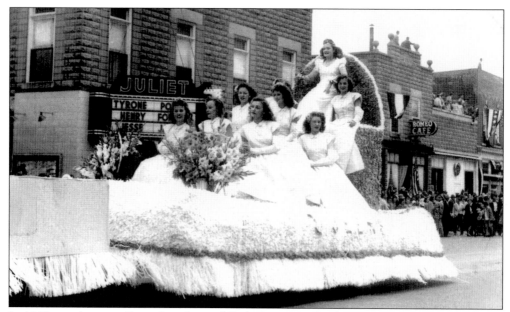

In 1946, peach queen Doris Sternberg of Oxford was on the throne surrounded by her court, from left to right, Gloria Tietz of Lapeer; Shirley Weirs, Miss Romeo of 1946; Noreen Warren of Port Huron; Evelyn Wiederhold of Macomb county; Georgia Wollnitz of Mount Clemens; Betty Uplegger of Imlay City; and Dorothy Henderson of Clio. On the block is the Romeo Café, originally opened by Mr. Heenan in the 1920s, and in the 1940s it was operated by John Shanlian. The eatery was sold to Edith Hill in 1952. Andy and Sally Hill operated it from 1972 until 1992. The current owners are Chris and Jennie Stevens. (Cox collection.)

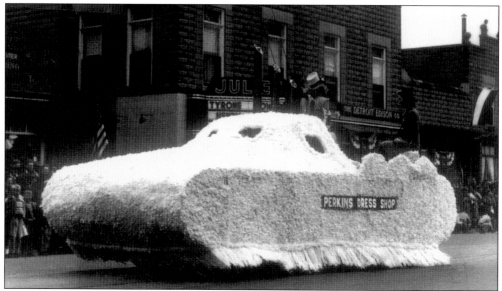

Perkins Dress shop also got into the festive mood by entering a float into the 1946 Floral Parade. This style of float is called "camouflaging the truck form," where the construction of the float covers the length of the entire vehicle. Here the float passes the Juliet Theatre and the Detroit Edison office, both housed in the Parker building built in 1905. Perkins Dress shop was located on North Main Street. (Cox collection.)

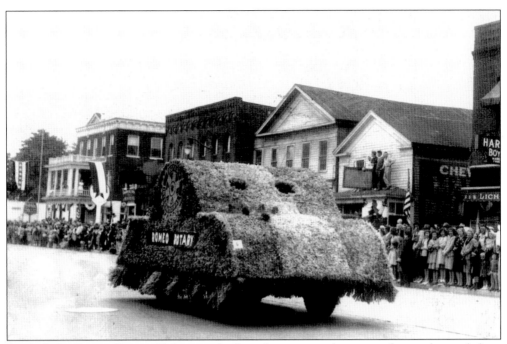

In 1946, the Romeo Rotary Club entered a float that was another camouflaging the truck form decorated in gold and blue. The float is traveling north on Main Street. In the distance is the Romeo Hotel and to the right two wood-framed buildings that were built around 1841 and demolished in 1989. (Cox collection.)

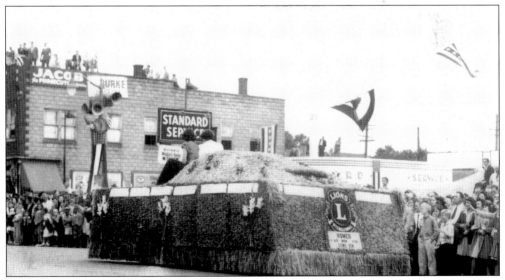

The Romeo Lions entered a float in 1946 that is shown here approaching the Arnold building on North Main Street. The Romeo Lions formed in 1942 and began their charity work for the Leader Dogs for the Blind. (Cox collection.)

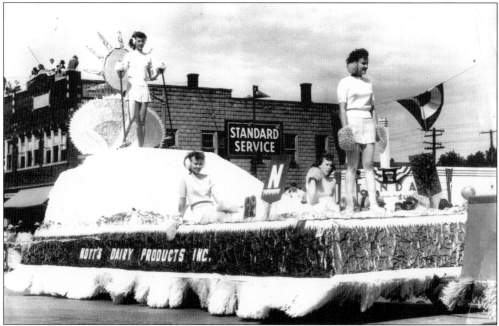

In the 1946 Floral Parade, Nott's Dairy Products entered another award-winning float. From left to right are Shirley Saul, standing on the ski slope; Gloria Schultz; Gena Bellman; and, standing firm, Velma Jean Schultz. At this moment, the float is gliding past the Standard station near the four corners. This building was razed in July 1970, having stood for 30 years. (Aikman collection.)

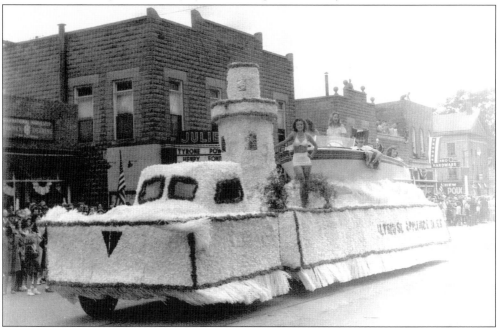

Awarded first place in the Floral Parade was Althouse Appliance Sales of Romeo. Ross Emerick, manager of the store, drives the large float complete with a lighthouse and a speedboat of bathing beauties. From left to right are Virginia Schmidt, Barb Lyons, Ross Emerick, and Lois Carpenter. (Cox collection.)

In 1947, peach queen Anna Mae Blue of St. Clair Shores traveled along with chaperone Mrs. Frank MacIntosh to Washington, D.C., to present Pres. Harry S. Truman four baskets of peaches. She met with William Simmons instead, who was the president's aide at the White House. He allowed her to sit in the president's chair. She also flew to Chicago to speak on the radio as a guest on Don McNeil's Breakfast Club, promoting the upcoming festival. (Cox collection.)

Siblings Judy and Jack Ruddick are photographed with the orange pumpkin float that the duo rode in the 1947 Children's Parade. It was built by their dad, Gordon Ruddick, in the back yard of the family home at 118 Tillson Street. (Rios collection.)

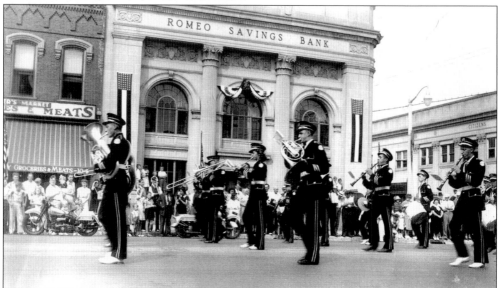

The Romeo High School marching band makes another appearance at the Floral Parade. At this time, it is passing in front of the Romeo Savings Bank, which was built in 1927. To the left is Baker's Market, which closed in 1945. (Cox collection.)

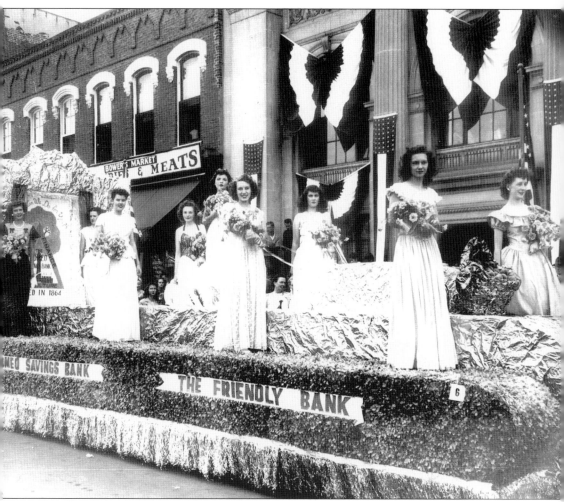

In 1947, the Romeo Savings Bank was the friendly bank. Imagine the tellers of today being forced to ride a float. From left to right are Shirley Glover, Audrey Barkley, Norma Greene, Gerry Anderson (sitting), Susan Chevrie, Jean Pevitt, unidentified, Shirley Kohlhagen, and Mary White. The float just happens to be passing in front of the bank building at 100 South Main Street. (Werderman collection.)

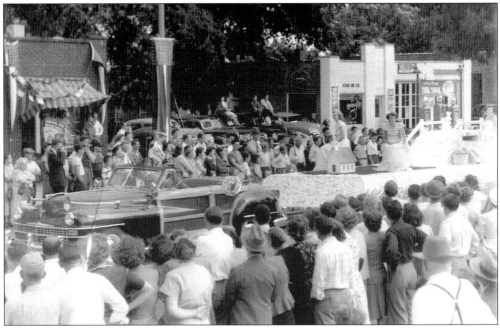

Around 1948, Bill Totten is in the driver's seat pulling the float representing the Peach Growers association, passing in front of the Star Oil station. That service station was once located at 159 South Main Street, and is now known as the Village Market. To the left is the Bauer's Garage building at 149 South Main Street. In 1974, a Little Caesar's pizza parlor would squeeze into the space between the two buildings. (Totten collection.)

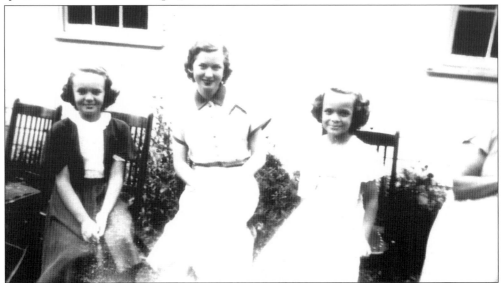

In 1948, Bernice Maddox of Flint was officially crowned peach queen at the opening ceremony of the festival at the high school auditorium. The 19-year-old former model was soon nicknamed "Peaches" by her family. During the weekend, a garden party was held at Mrs. James Wilborn's home on West St. Clair Street and drew a large crowd. Bernice Maddox took the time to chat with her young fans. Sitting in the back yard, enjoying the afternoon, are, from left to right, Nancy Martell, queen Bernice Maddox, and Mary Martell. (Schmidt collection.)

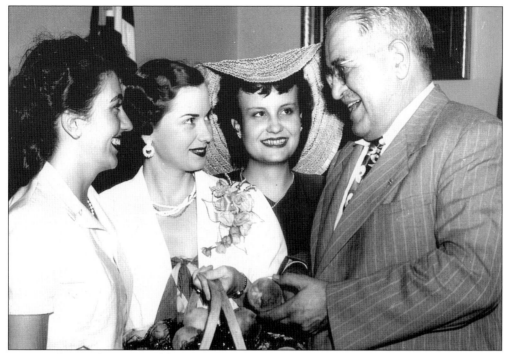

In 1948, the peach queen and her court presented a basket of peaches to Detroit Mayor Eugene Van Antwarp. From left to right are Evelyn Polk of Mount Clemens; queen Bernice Maddox; Velma Jean Schultz, Miss Romeo of 1948; and Eugene Van Antwarp. Later the trio and their chaperone took a tour of the Michigan State University campus and did a radio broadcast from the college radio station. They also enjoyed an afternoon game at Briggs Stadium and presented peaches to Tigers manager Steve O'Neil. (Schocke collection.)

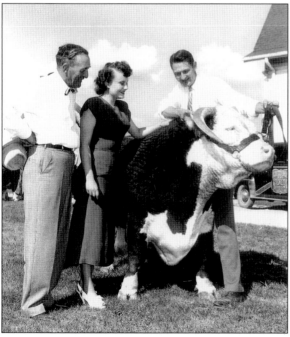

Miss Romeo of 1948, Velma Jean Schultz, posed with T. T. Regent, a $50,000 herd bull, at the Hi Point Farms located on 34 Mile Road. Hi Point was a 2,000-acre farm owned by Edward F. Fisher of the Fisher Body fame. Later, in 1955, the property become the Ford Proving Grounds. From left to right are Frank MacIntosh, who was the president of the Peach Festival Association; Velma Jean Schultz; and Dr. Louis Newlin, also a member of the festival committee. (Havers collection.)

In 1948, a group of girlfriends team up to enter the Mummer's Parade. From left to right are Julie Kalinowski, Janet Stirling, Barbara White, Vera White, and Betty Thompson, photographed in the backyard of the former 226 North Bailey Street. In 1948, the parade time slot was changed from Monday, Labor Day, to the Sunday night prior. (Brandt collection.)

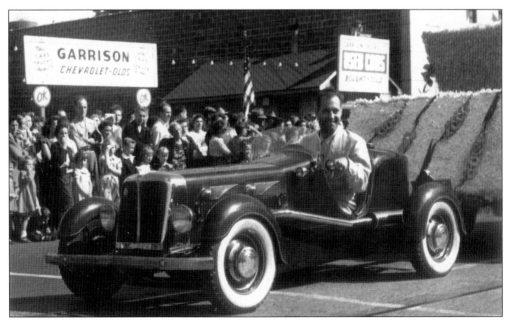

Car collector James Schocke drives a French-built Mathis roadster that is pulling a float near the Garrison Chevrolet dealership, next to the Romeo Theatre, on South Main Street. Schocke was later president of the peach festival committee around 1963 and was a member of the Lions since 1942. Later he became a Bruce Township supervisor in 1969 and the Justice of the Peace for Shelby and Bruce Township for 13 years. (Schocke collection.)

In the 1947 Children's Parade, Judy Ruddick peddles her tricycle to pull her oversized valentine heart, representing the month of February, as the parade theme that year was the months of the year. An early morning rain did not discourage the kids from having fun. The parade this year began at the North Grade School at Hollister and North Main Streets moving south to Lafayette Street and returning back. (Rios collection.)

Behind her peddling just as hard was brother Jack Ruddick who is getting a little help from his father, Gordon Ruddick. Jack seems to be more interested in the parade that is traveling south in the other lane. His choice was the month of March, celebrating St. Patrick's Day with a green and white four-leaf clover. Gordon Ruddick was also a peach festival committee member. (Rios collection.)

This trio is representing the month of June. From left to right are Ron Schocke as the judge, with brother Gary Schocke and cousin Darlene Walker as the bride and groom. Gary Schocke would later become president of the peach festival committee in the late 1990s through 2006. The rain at the 1947 peach festival dampened things a little bit, but still over 50,000 attended the weekend festivities. (Schocke collection.)

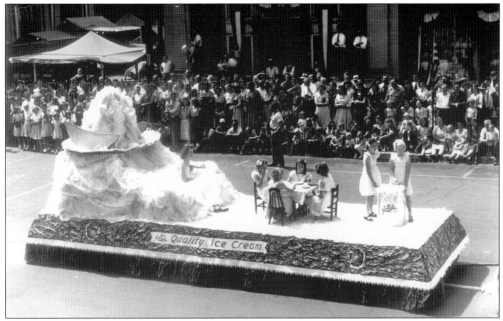

The fine work of local photographer Ed Allam, who shot these 1948 photographs, is seen here. Local merchant Perry Nott always went overboard for prize-winning floats. Here in 1948, he won third place for his peach sundae with a dairy queen and a cool ice cream party for six girls. Note that West St. Clair Street is the site of the game and refreshment tents. (Cox collection.)

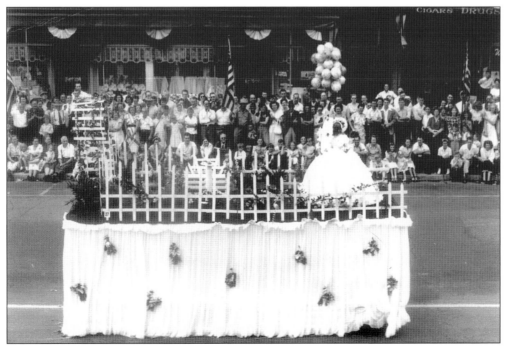

The first-prize award in the 1948 parade went to River Bend Farm from Imlay City. The float featured a young girl who tends to her garden. On the sidewalk, a balloon vender stands near the D&C and Weeks Drug store on North Main Street. (Cox collection.)

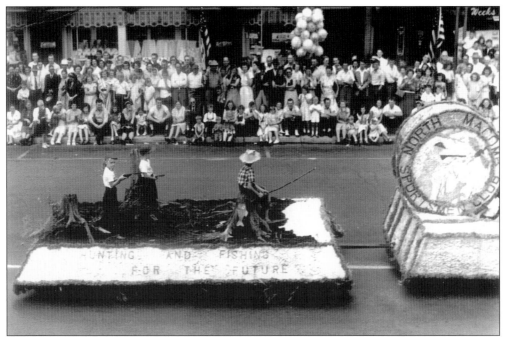

The 1948 second-place winner in the Children's Parade was the North Macomb Sportsmen's Club. The prior year, with a different float, they placed fifth in the parade. The club, established in the 1940s, is located on Inwood Road in Washington Township. (Cox collection.)

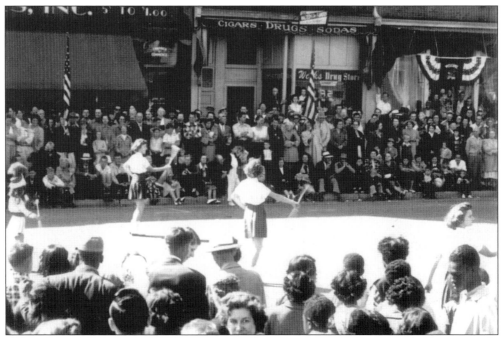

This is the same location but a different year, and a different parade. Shown is the beginning of a high school marching band passing the D&C and Weeks Drug store. The girls are twirling their batons to the beat of the music to the amusement of the crowd. (Bishop collection.)

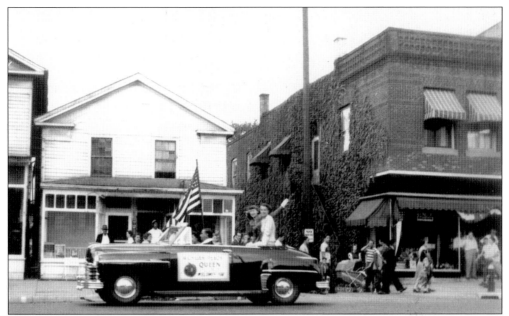

This view shows the parade in 1949 passing 120 South Main Street. To the right at 112 South Main Street is Chamberlin Hardware, operated by Cass Chamberlin who had purchased the Licht Hardware in 1948. The alley was lost with an expansion of the hardware store years later. That is the peach queen in the Children's Parade in the morning hour. (Bishop collection.)

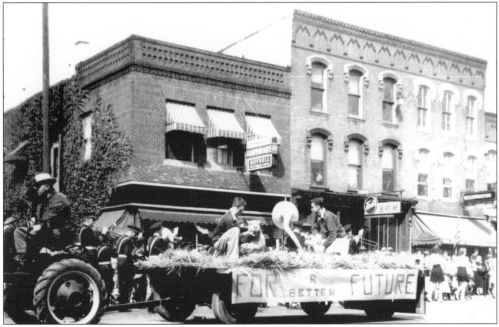

This is an agriculture float represented by the 4-H club members. Two boys hold the sheep as they look for a better future. Note the band on its return route passing the float. This was common in the early years that the parade would backtrack to the starting point. In the background are Chamberlin Hardware and Ted's Bar. (Bishop collection.)

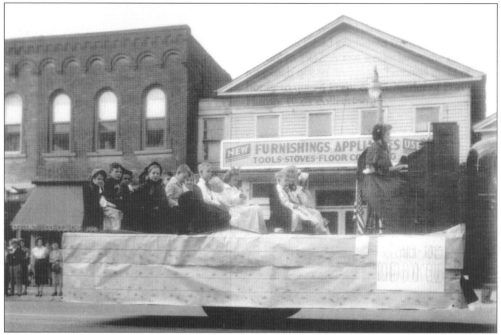

The First Church of Romeo and the Romeo Book Club team up for a float in the c. 1949 Children's Parade. The youngsters sitting in the four pews are singing hymns along with a piano backing. The float is passing 124 and 120 South Main. (Bishop collection.)

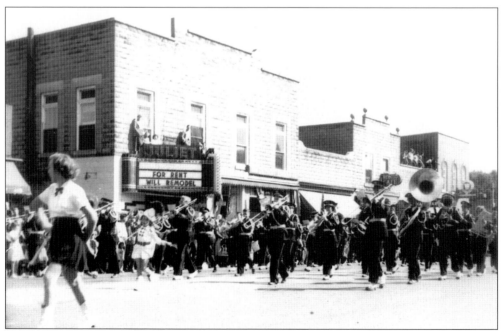

The Romeo High School band marched in front of the Juliet Theatre one last time around 1949. The theater went out of business, edged out by the modern Romeo Theatre just a block down the street. The interior was later remodeled and became the new home of the Romeo Bakery for many years. (Bishop collection.)

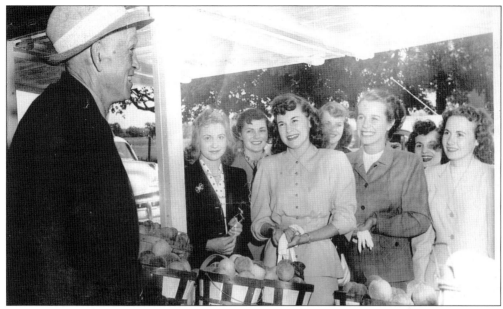

The 1949 peach queen Barbara Greene and members of her court were given a tour of the local orchards. The group made a visit to West View Orchards located at the corner of 30 Mile Road and Van Dyke Avenue. The girls are meeting owner Harvey Bowerman at the fruit stand to sample the peaches and learn about retailing. From left to right are Harvey Bowerman, Ruth Raeburn from Romeo, Marjorie Lou Leesch of Mount Clemens, peach queen Barbara Greene of Pontiac, June Hasenauer of Roseville, Arlene Andress of Lapeer, Fay Tallman of Clio, and Greta Murray of North Branch. (Westview Orchard collection.)

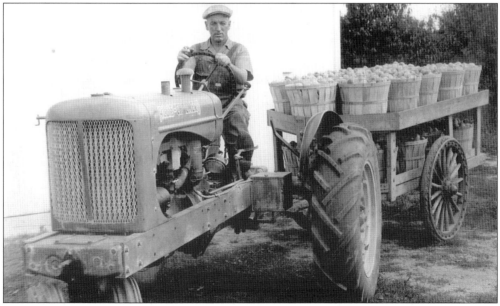

Herman Rapp is on his Allis-Chalmers tractor pulling a load of freshly picked bushels of peaches around late 1940s. Rapp, hired by Harvey Bowerman, arrived from Germany in 1934 and worked for a short time at Westview Orchard. He later split a parcel of land with Henry Verellen and opened H. Rapp Fruit Orchard around the 1940s. (Rapp collection.)

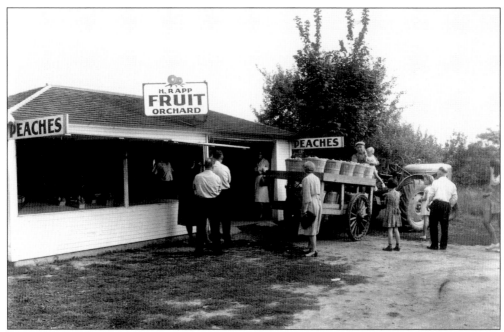

The original H. Rapp Fruit Orchard stand was located on the east side of Van Dyke Avenue. Herman Rapp can be seen lifting a child off of the tractor, possibly giving him a ride from the fields shown here in 1949. The retail stands were always busy, as they sold the freshest produce. (Rapp collection.)

The produce stand was relocated across the street, shown here around 1951. At this time, the name was shortened to Rapp's Orchard. In 1970, the orchard was operated by Karl and Karen Rapp, who later expanded the stand into a larger building with more retail. They grew peaches, apples, plums, and cherries until they closed in 2005. (Rapp collection.)

Three

THE 1950S

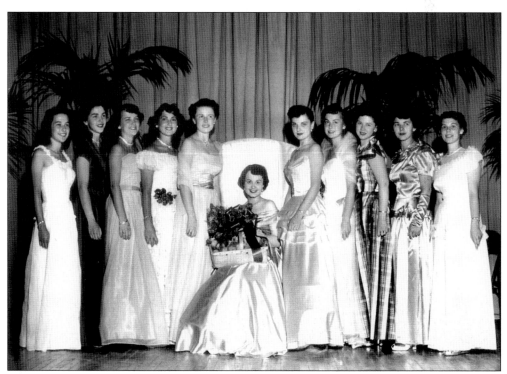

The 1950 peach queen, Rosemary Murray, and her court posed on the high school stage. From left to right are Alma Jones of Fair Haven; Suzanne Chubb, Miss Romeo of 1950; Joyce Haggberg of Algonac; Lillian Anton of Mount Clemens; Eleanor Laich of New Haven, the first maid of honor; queen Rosemary Murray of Pontiac; Joy Tosichcs of Pontiac, the second maid of honor; Joyce Bradley of Dryden; Betty Joan Clark of Flint; Patricia Hauck of Birch Run; and Bethany Ann Nagy of Lapeer. (Winkler collection.)

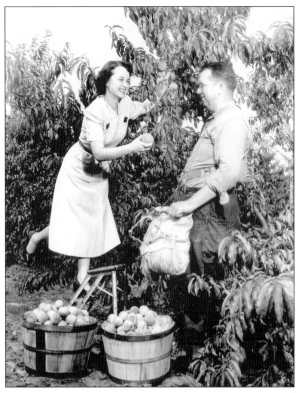

Peach queen Rosemary Murray poses with Jerome Schoff, the president of the Romeo Peach Growers association. This photograph was taken on August 29, 1950, at Schoff's Pine Grove Orchard located on Campground Road near 33 Mile Road. (Kasuri collection.)

In the 1950s, the queen's coronation ceremonies were still a big lavish production. This year it was held in the Memorial Field between Chandler and Morton Streets. Dressed as a herald, Gary Corbin along with Charles Rhodes would begin the procession to the stage with their trumpets. *Detroit Free Press* writer and poet Edgar Guest crowned the peach queen at the ceremony. Corbin is seen here in his parents' back yard posing in costume. (Corbin collection.)

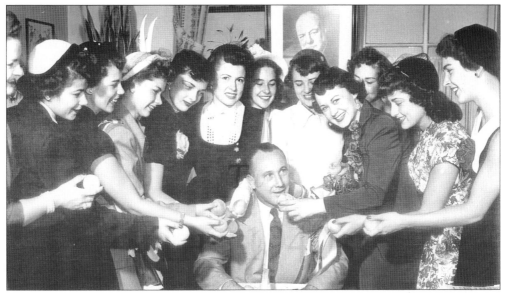

The 1950 queen and her court went to the Detroit Athletic Club for a meet and greet. From left to right are chaperone Gen Kasuri; Betty Joan Clark of Flint; Patricia Hauck of Birch Run; Joyce Bradley of Dryden; Joy Tosichcs of Pontiac, the second maid of honor; Eleanor Laich of New Haven, the first maid of honor; Alma Jones of Fair Haven; Joyce Haggberg; queen Rosemary Murray of Pontiac; Ann Nagy of Lapeer; Lillian Anton of Mount Clemens; Suzanne Chubb, the Miss Romeo of 1950; and Walter B. Cary seated in the center. (Kasuri collection.)

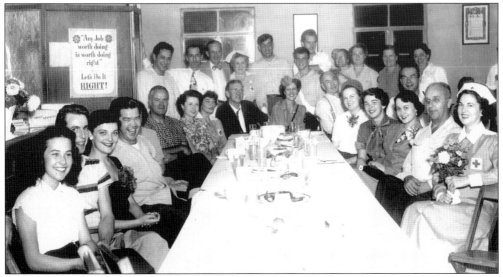

Around 25 veterans from the Marine Hospital on East Jefferson Avenue in Detroit made a trip to Romeo to visit Mountain View Orchards. Lee Barrows, manager of the orchard, provided peaches and apples and a game of horseshoes to the veterans. They also toured Hel Roy Farms and Hi Point Farms. In the evening, the American Legion and the Red Cross served a chicken dinner for the men and their guests at the Veterans Hall (American Legion Hall) at 275 East Gates Street. To the right, mixed in the crowd, are Gen Kasuri, Suzanne Chubb, and queen Rosemary Murray. (Kasuri collection.)

In 1951, Michigan governor G. Mennen Williams crowned the queen at the coronation ceremony that was held on the stage in the high school gymnasium. Due to the rainy weather, the event was moved inside from the football field across the street. From left to right are Governor Williams, two unidentified children, and peach queen Joann Calvert of Lapeer. That year, 1951, is when the Romeo Lions sponsored the peach festival, and it went very smoothly. Ed Jacob was back on the festival committee and helped with his knowledge of running the festival. (Cox collection.)

Governor Williams is about to retrieve the crown from the crown bearer during the coronation ceremonies. From left to right are Gov. Williams, Terry Bower, queen Joann Calvert, Guy Wilcox, and Carol Emmett, the trainbearers. The view of the stage from the balcony seats and the wall bleachers was perfect for the large audience that attended. (Cox collection.)

The 1952 peach queen was Diona Coval of Utica. She is photographed here on August 22, at the capitol steps, to take a bite of her peach and promote the upcoming festival. On August 25, Coval went to Washington, D.C., to present peaches to President Truman's representative. While in Washington, she met actor Jimmy Stewart. (Cox collection.)

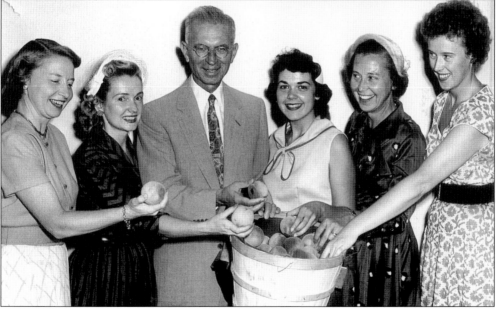

In 1953, Nancy Seeman of Utica was also crowned peach queen by Gov. G. Mennen Williams. On a trip to Washington, D.C., the queen and her chaperone presented a bushel of peaches to President Eisenhower's representative. From left to right are two unidentified women; Ezra Taft Benson, who was the secretary of agriculture; queen Nancy Seeman; queen's chaperone Eleanor Ferrara; and unidentified. A few years later, Nancy Seeman married Detroit Tiger Duke Mass, who was originally from New Haven. (Cox collection.)

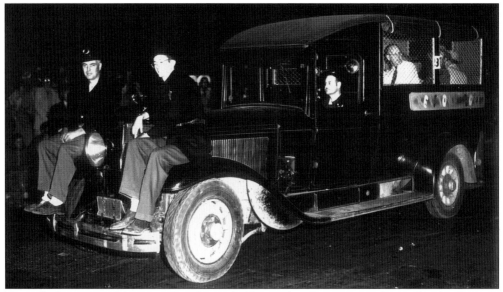

From the beginning, Mummers Parade was held on Labor Day evening, being the third parade of the day. It was intended to hold the interest of the visitors and keep them here to eat, drink, mock the floats, and enjoy the final hours of the festival. It was moved to Labor Day eve in 1948. Around 1951, the Romeo Lions Club spoofed the Keystone Cops that would force people to appear in front of the Kangaroo Court. The officers, in no particular order here are Bert Kernaghan, Harold Hermann, and Walter Huston, would arrest unsuspecting spectators and haul them off in the back of the paddy wagon. (Cox collection.)

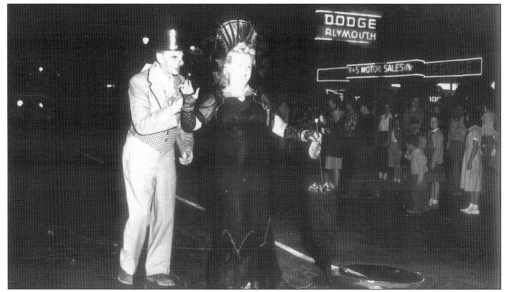

Around 1951, the belle of the Mummer's Parade would be Wanda "Blondie" Jamison of nearby Washington, who would dress as the Black Maria and flirt with the men in the crowd and have them arrested for misbehavior. Even worse, she was accompanied by her husband, Herbert Jamison, who was dressed like W. C. Fields, with a fake nose and top hat. The duo entered the parade a couple of years. The neon sign of the Dodge Plymouth auto sales is lighting the night. (Cox collection.)

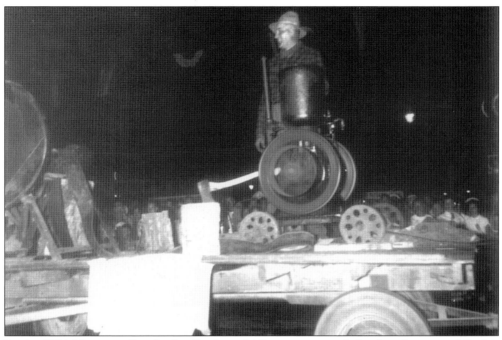

In the 1954 Mummers Parade, Jay Pardon of Allenton accepted the first-place award for his woodchopper float. An inventor of sorts, this man displays his motorized woodcutter. The sharp axe whacks logs with such force it splits them in two. The nighttime parade was a time when anything goes. (Hennig collection.)

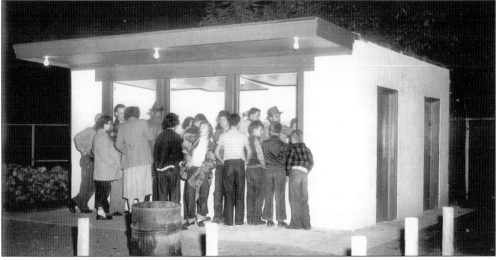

A crowd is shown at the concession stand at the football field around 1952. On September 17, 1948, Memorial Field was dedicated to those who lost their lives in World War II. It was property that the Romeo Lions owned and swapped for property that the school district used as a sports field located between Bailey and Denby Streets, the school receiving a better location for an athletic field and the Lions a new site for a future fairgrounds. Ed Jacob, who was living at 295 Chandler Street, donated a narrow catwalk from Chandler Street into the stadium. The Rotary group raised funds to give the new stadium lights, a fence, and goal posts, all in place for the opening high school football game with Marine City. (Cox collection.)

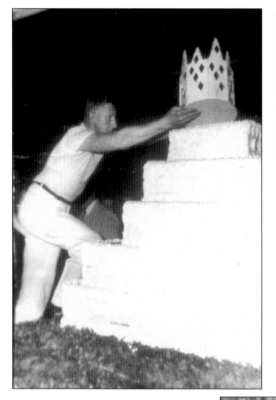

Romeo baker Donald McLeod puts the finishing touch, the crown, on top of the cake for the coronation festivities around the early 1950s. The six-foot, six-layer frosted cake was served on a decorated farm wagon located in the village park. McLeod, who operated the Model Bakery in Pontiac, moved to Romeo in 1951 and bought Otto Bittner's bakery and reopened it as the Romeo Bakery and stayed in business until 1964. (Beatham collection.)

Marv Blackett whips it up on the drums with the Blue Note Orchestra at the Queen's Ball at the Romeo High School gymnasium in 1953. Blackett was the Romeo member of the Port Huron based 10-piece orchestra and performed with them for one year. In 1948, he opened Marv Blackett Romeo Florist at 381 South Main Street, which closed in 1982. (Romeo Observer collection.)

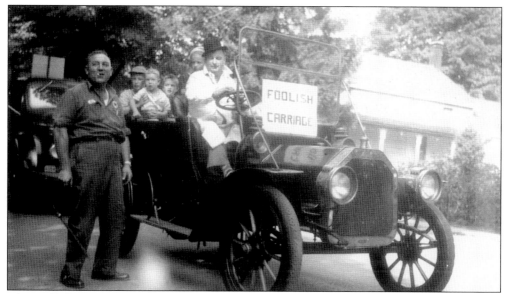

They called this entry the Foolish Carriage in the 1951 Mummers Parade. From left to right are Ken Posey, three unidentified people, Gene Hennig behind Bill Totten, the driver, with Marguerite Hennig in the passenger seat. The 1908 Buick that started with a hand crank was once owned by Dr. Frappier. The car actually overheated at the end of the parade due to the load of passengers. (Hennig collection.)

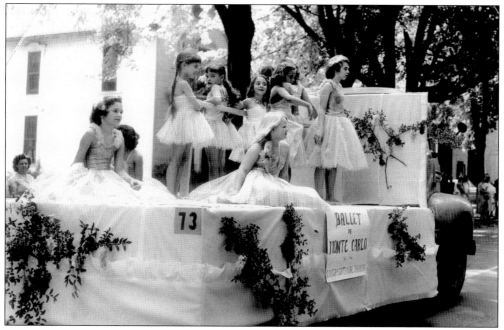

The Ballet of Monte Carlo came a long way to perform at a mid-1950s Children's Parade. On the left is Mary Martell sitting along side Julie Kost with Ellen Mosher dancing directly behind her and Judy Barnabo on the far right. The other Romeo girls are unidentified but attended a ballet class in the basement of the Congregational church under the direction of Russian dance instructor Miss Eugina. (Raymond collection.)

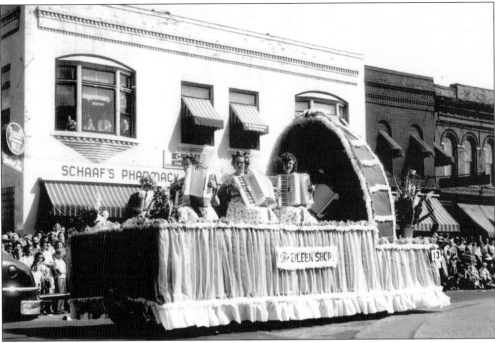

All together now, ladies we only do this once and no waving to the crowd. The Eileen Shop was a women's clothing store operated by Eileen Brandenburg and was located at 224 North Main Street. The accordionists are talented but are unidentified. (Cox collection.)

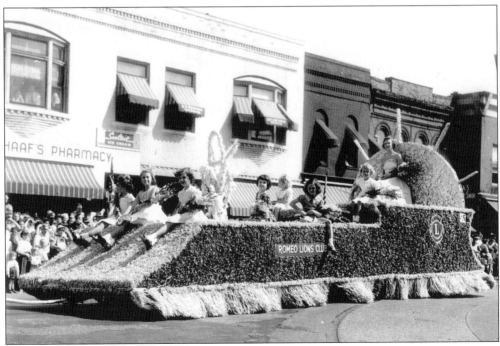

The Romeo Lions Club float is passing at the center of town around 1951. Dr. Nott's staff and family are enjoying the view from his second floor office window above Shaff's Pharmacy. (Cox collection.)

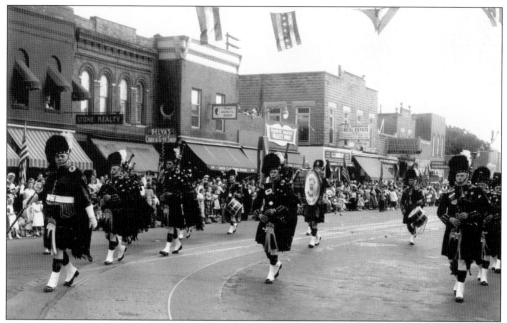

Bagpipers, always a popular addition to the parade, march down Main Street around 1951. Note the old interurban railway tracks curving toward West St. Clair Street. The trolley was once part of a transportation system linking Romeo with other communities; it went out of service in 1931, and the tracks were paved in place. (Cox collection.)

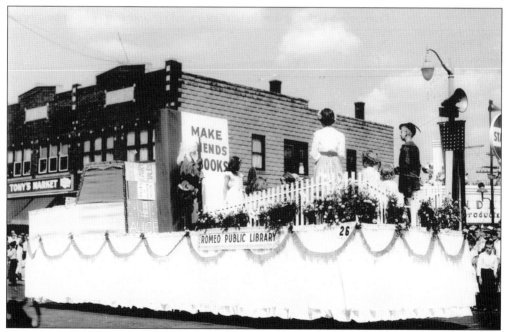

The Romeo Public Library entered a float in the Children's Parade around 1951. "Make Friends In Books" is the theme, not "How To Look at the Camera" since none of them can be identified. The fairy-tale characters are as diverse as Robin Hood, Heidi, and Johnny Appleseed. (Cox collection.)

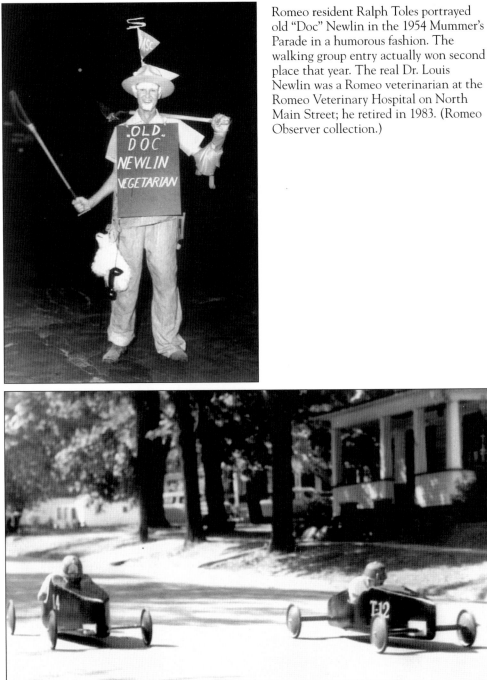

Romeo resident Ralph Toles portrayed old "Doc" Newlin in the 1954 Mummer's Parade in a humorous fashion. The walking group entry actually won second place that year. The real Dr. Louis Newlin was a Romeo veterinarian at the Romeo Veterinary Hospital on North Main Street; he retired in 1983. (Romeo Observer collection.)

In 1954, the boys coaster race was held on West St. Clair Street. Donald Wake of Detroit won driving his T-12, which grabbed an early lead in the final race and went on to capture the first-place award. Wake is passing to the left Alex Krukowski of Detroit, the second-place winner. After a number of elimination races, the field narrowed down to three contestants. Most of the drivers were from out of town, as they were veterans of the famed Soapbox Derby races in Detroit. (Romeo Observer collection.)

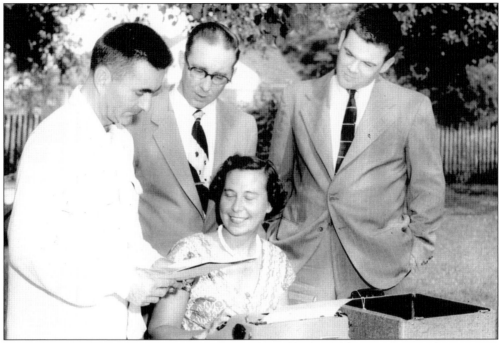

Peach festival committee members go over the new festival by-laws of the Romeo Festival association. From left to right are Charles Meeker, Phillip Davidson, Eleanor Ferrara, and Gerald McLean. The group planned the press releases and the schedule of events and contacted the Michigan governors to be invited. All their meetings were held outside. (Romeo Observer collection.)

The 1955 peach queen, Nancy Kovack of Flint, and her chaperone, Shirley Poosch, are arriving in Washington, D.C., to present a peach pie to Congressman Jesse P. Wolcott. After her stint as a queen, Kovack went to New York and worked on the Jackie Gleason *Today Show* as a dancer. She later moved to Hollywood and did feature films for Columbia and Paramount Pictures. In 1965, she landed roles in *Frankie and Johnny*, starring Elvis Presley, and *The Outlaws is Coming*, a western comedy with the Three Stooges. Her television was resume just as impressive: *Bewitched*, *Get Smart*, *Star Trek*, *I Spy*, *It Takes a Thief*, and *Batman*. It was her 1969 role in *Mannix* that earned the actress an Emmy nomination. (Cox collection.)

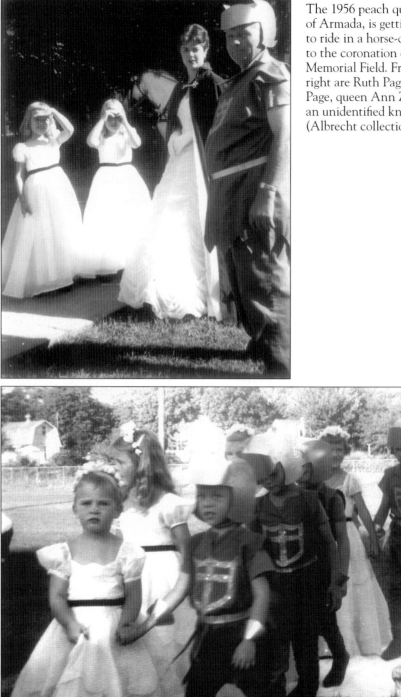

The 1956 peach queen, Ann Zemke of Armada, is getting prepared to ride in a horse-drawn carriage to the coronation ceremony at Memorial Field. From left to right are Ruth Page, Mary Ann Page, queen Ann Zemke, and an unidentified knight driver. (Albrecht collection.)

After the ceremony was over, the tiny future queens and their knights file out from the platform. The children were students of Mrs. Albrecht's kindergarten class at South Grade School. Some of the ones that participated were Kathy Simmerman, Pam Nauseda, and Eddie Nauseda. (Albrecht collection.)

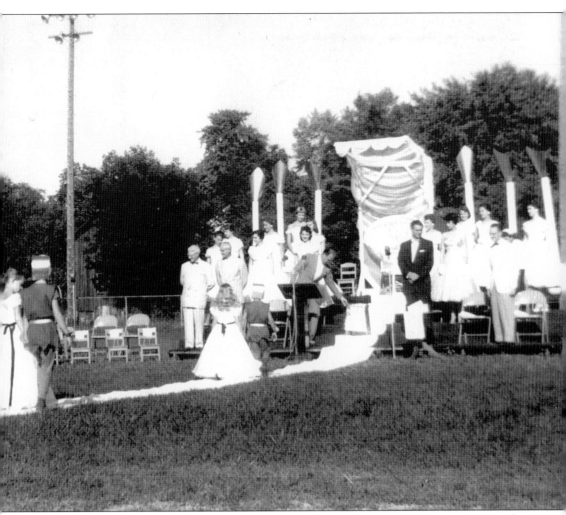

During the 1956 peach queen coronation ceremony, Gov. G. Mennen Williams welcomes the tiny future queens to the platform where the queen's court is already in place. The queen would arrive moments later in her horse-drawn carriage. Sitting in her throne, queen Ann Zemke would receive her scepter from Pat Dallwitz, Miss Romeo of 1955, who was standing in for absent queen Nancy Kovack. Attending were thousands of spectators who crowded the bleachers and lined the hill at the afternoon event. (Albrecht collection.)

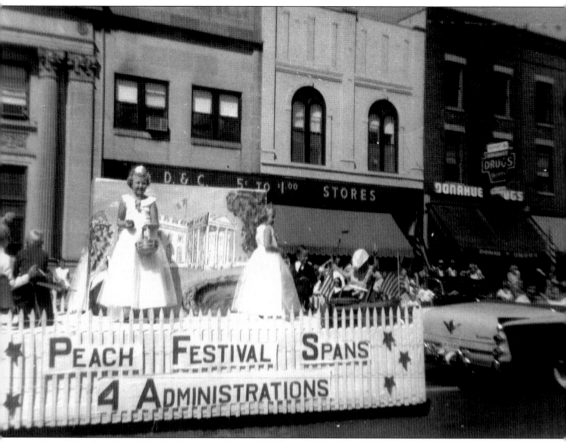

In 1956, the float "Peach Festival Spans 4 Administrations" won first place in the large float division in the Children's Parade. Seated in front of the White House were David Appel as Roosevelt, Douglas Ludtke as Truman, Duane Appel as Eisenhower, and Dennis Appel as Hoover. The girls as first ladies were Sue Ann Ladd, Diane Appel, Mary Alice, and Jeannie Ludtke. Later in the day, the float placed third in the Floral Parade. (Cox collection.)

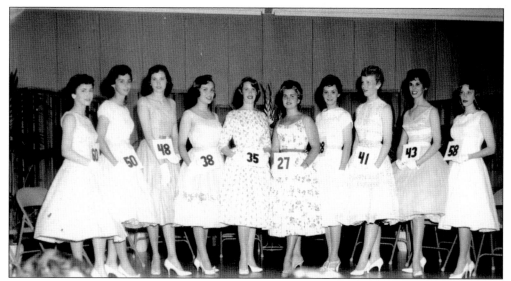

The Miss Romeo contestants on the stage of the Romeo Youth and Civic Center on June 4, 1959, are, from left to right, Shelia Dahn, Janet McIntyre, Nancy Rainer, Mary Martell, Teddy Schanck, Margie Devine, Connie Linteau, Linda Fetter, Sue Dallwitz, and Pat Russell. The girls were judged based on the following points: poise, beauty, personality, and speaking ability. The only requirement to enter was one had to be between 18 and 24 and live in Romeo. (Ruggirello collection.)

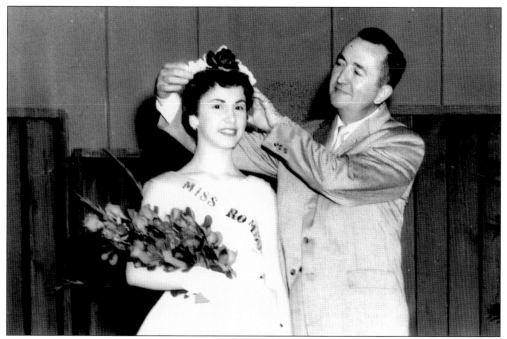

That evening, Shelia Dahn, Miss Romeo of 1959, was presented with a bouquet and crowned with a floral tiara from peach festival chairman Herbert Miller. The new youth center on Morton Street was the new home for the pageants. Its modern design included a stage complete with spotlights and draw curtains, adding some much-needed life to the nearly 30-year-old pageant. (Ruggirello collection.)

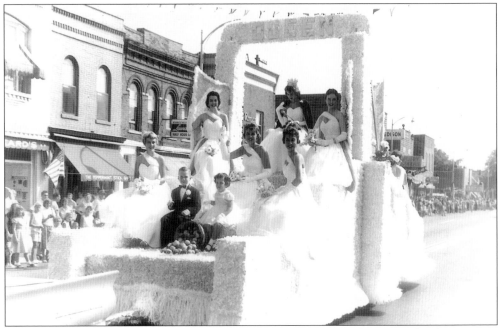

The 1959 peach queen, Lorelei Hoxie of Armada, rides atop the float near the four corners of town. The 18 year old was a 1959 graduate of Armada High School. There was no trip to Washington, D.C., this year. The queen was the guest of Flint, where she appeared on a local television program and was featured in the *Flint Journal* newspaper. (Ruggirello collection.)

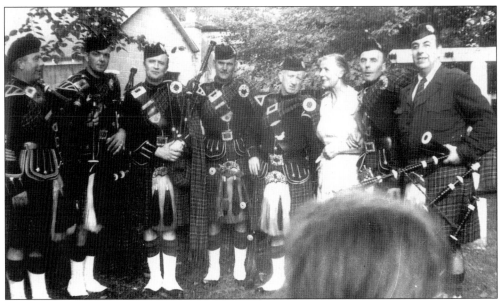

For a few years, bagpipers would return to Ann and Oliver Stirling's home at 228 North Main Street and perform in the side yard. The Stirlings emigrated from England and would cook a meal for their Scottish friends. In return the band would play an impromptu set in the side yard. Ann Stirling is standing with the musicians in the late 1950s. (Stirling collection.)

Four

THE 1960S AND 1970S

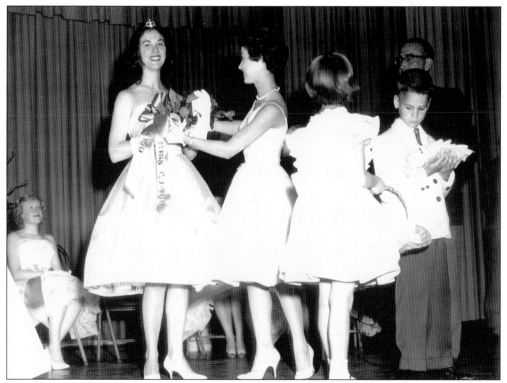

Miss Romeo of 1960, Sharon Poljan, is greeted by Shelia Dahn as she hands down the tiara. Sharon is the daughter of Mr. and Mrs. Richard Poljan and the sister of Patricia Poljan, who had won the title of Miss Romeo in 1954. Miss Romeo and her court appeared in the Festival of Roses Parade in Roseville, pickerel festival in Algonac, and the Fourth of July parade in Utica. (Ruggirello collection.)

Virginia Verellen won the Miss Romeo pageant of 1962. Photographed on the youth center stage are, from left to right, Delphine Browarsk, the second runner up; Miss Romeo Virginia Verellen; and Beverly Warren, the first runner up. Miss Romeo and her court took in a Tiger game and took a visit to the Hazel Park Raceway. (Bjornstad collection.)

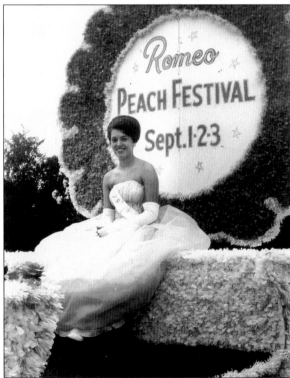

The 1962 Miss Romeo rides on the new float in the Floral Parade. Virginia Verellen was the only girl to win in festival history to represent an orchard family. Her grandparents Ed and Theresa Verellen purchased Munger's Farm located on Van Dyke Avenue in 1920. In 1943, son Joseph Verellen opened Green Leaf Orchard. Virginia's parents, Joseph and Gladys Verellen, continued the orchard, located formerly at 11731 29 Mile Road, near the corner of Van Dyke Avenue, into the 1970s. (Bjornstad collection.)

The 1964 peach queen, Pamela Cumming, became the third local girl to win the title. On a trip to Washington, D.C., she, along with her chaperone, Raydith Austin, presented a basket of peaches to Speaker of the House John W. McCormick and Macomb County Congressman James G. O'Hara at the U.S. Capitol. (Corbin collection.)

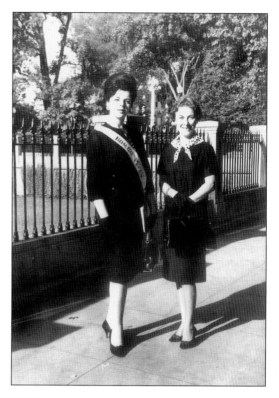

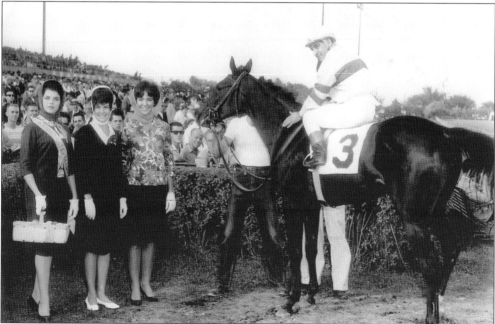

The peach queen and her maids of honor meet professional jockey Tommy Lattarulo on his horse Sneer, winner of the fourth race, the special Romeo Peach Queen Race, at the Hazel Park Raceway course on August 25, 1964. From left to right are peach queen Pamela Cumming of Romeo, Nancy Gay Shadrick of Waterford, and Barbara Walter of Armada. (Corbin collection.)

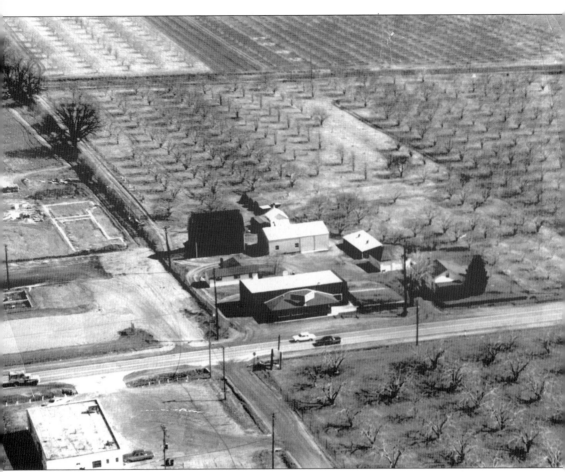

Shown here is an aerial view of Southview Orchard in 1965. The large orchard and farm was located on Van Dyke Avenue between 30 and 29 Mile Roads. The building on the bottom left was once the Otto and Frank's meat market. Rapp's orchard property is in the right corner. Behind the brick produce stand, built in 1950, is the original wood stand that they opened in 1933. Southview Orchard would close in 1997. (Knittel collection.)

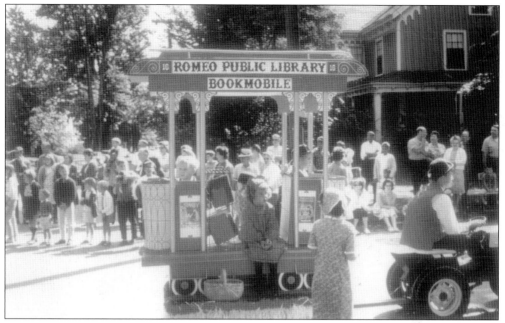

The Romeo Public Library entered a small float in the 1966 Children's Parade. A few of the library's storybook hour kids are riding a miniature book mobile. From left to right are Curt Raymond, Debbie Frost, two unidentified, and Tom Raymond driving the lawn tractor, all passing in front of 264 North Main Street at the corner of Dickinson Street. (Raymond collection.)

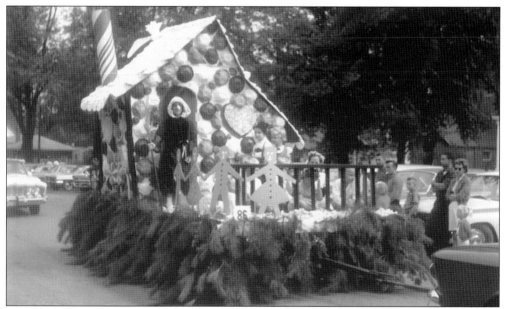

The theme for the 1963 Children's Parade was "A Child's World," and the first-place winner in the large float category was the entry from the Herb Miller, Ora Smith, and Clare Dewey children. The Hansel and Gretel float featured a candy cottage covered in gumdrops and bonbons and was a big hit with the youngsters. The float is parked on North Rawles Street near the village park. (Smith collection.)

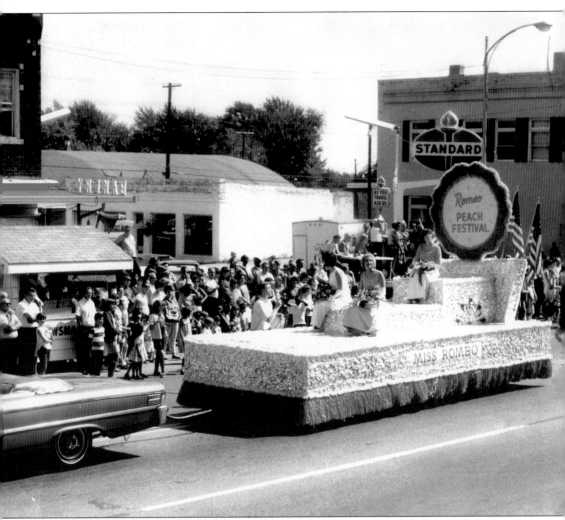

The Miss Romeo float is passing the center of town in the 1967 Floral Parade. From left to right are Francine Eterno of Washington, the third runner up; Ann McLaughlin, the fourth runner up; and Miss Romeo proxy Karen McLaughlin. Note the remote radio booth to the left as the parade coverage was aired on an AM station. The newscaster is interviewing a member of the court. Also the elevated judges' stand is visible behind the float. (Conrad collection.)

In 1967, Annette Scheuneman was crowned Miss Romeo, but for the Floral Parade the first runner up, Karen McLaughlin, the daughter of Lawrence and Patricia McLaughlin of Chandler Street, was called to duty to stand in for the absent Miss Romeo. (Conrad collection.)

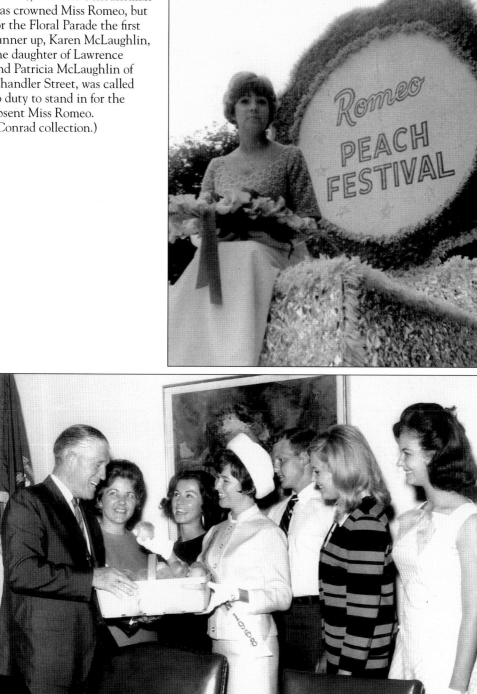

Michigan Gov. George W. Romney greets the 1968 peach queen, Donna Jean Christenson of Flint, and her court with other visitors at the State Capitol in Lansing. From left to right are Governor Romney, unidentified, the queen's chaperone Shelia Ruggirello, queen Donna Jean Christenson, and three unidentified visitors. (Ruggirello collection.)

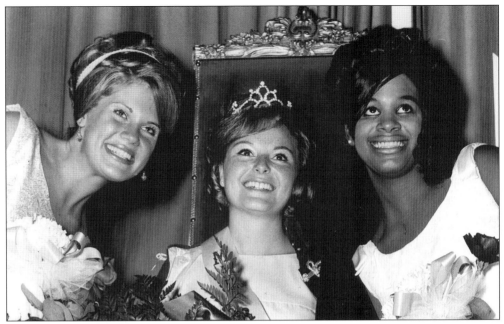

On June 22, 1968, Francine Eterno of Washington was crowned Miss Romeo. From left to right are Janis Pierce, the first runner up; Francine Eterno; and Sherryl South, the second runner up. Sherryl was the daughter of Mr. and Mrs. Sherman South of Dorsey Street. (Romeo Observer collection.)

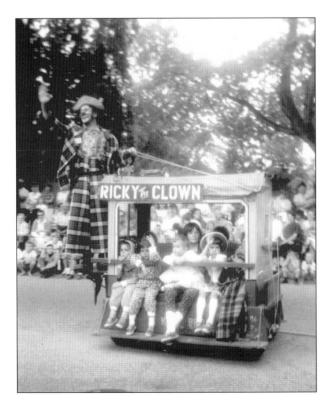

Ricky the Clown appeared at the Floral Parade in 1966. His routine included honking horns, spraying the crowd with water, and making balloon animals. Seated in the small caboose is a group of children going for a short ride. On the far left is Patricia Bell, the daughter of lifelong resident Della Belle, who was the grand marshall of the Floral Parade in 2005. (Bell collection.)

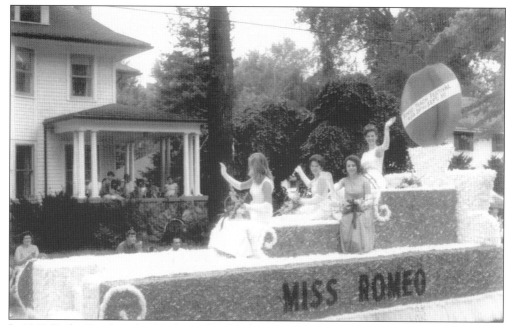

In 1969, Kathy Gondert, the daughter of Ted and Jean Gondert of North Main Street, won the Miss Romeo pageant. From left to right are Melanie Sutter, the second runner up; Patricia Desmond the third runner up; Barbara Falker, the first runner up; and Miss Romeo Kathy Gondert. The float is gliding in front of 404 North Main Street. That year a new float was used; it was decorated in gold and white with an oversized peach behind the throne. (Gondert collection.)

The evening ends with Patrice Desmond sobbing over hearing that she is Miss Romeo of 1970. Kathy Gondert enters the picture to congratulate the winner who is seated center stage. Desmond would become first runner up to peach queen in 1970. At the last Miss Romeo Pageant in 1973, Cynthia Geisler won the title. (Gondert collection.)

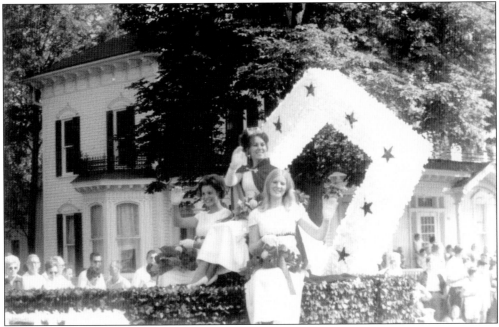

The float that the 1970 peach queen, Karen Lloyd of Beaverton, is riding is passing 185 South Main Street. From left to right are first runner up Patrice Desmond, queen Karen Lloyd, and second runner up Francis Ann Juliano of Roseville. For her promotional tour, the queen went to Washington, D.C., and met with Congressman James O'Hara and presented peaches to Secretary of Agriculture Clifford M. Hardin. (Raymond collection.)

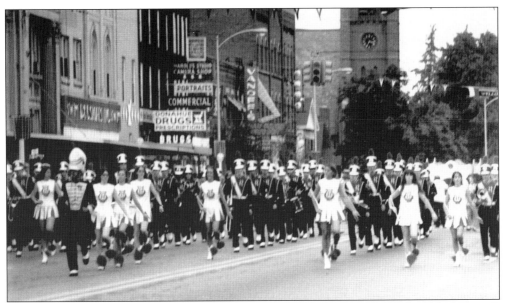

The Romeo High School marching band, fronted by the majorettes, is marching down North Main Street in the 1970 Floral Parade. This is an interesting look at all the signs that once lit up downtown. Shown are the D&C store, Donahue Drugs, Harold's Studio and Camera shop, Vanoff's Restaurant, and the original four Masonic temple white globes. (Raymond collection.)

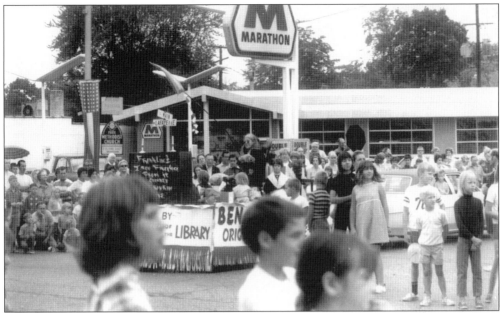

The 1970 Children's Parade is making a turn on to West Lafayette Street from South Main Street. The Ben Franklin float was entered by the Romeo District Library. In the background is the Marathon gas station built in the mid-1960s at the site of the old Romeo Hotel. (Raymond collection.)

Another entry in the 1970 Children's Parade, the Steward family, entered a group of early settlers with a covered wagon en route way out west. From left to right are Terry Steward, Rena Steward, Nina Steward, Slyvia Steward, and Paul Steward. The family is passing in front of the former Cedar Inn bar at 128 North Main Street. The bar was established in the late 1930s and became Thee Office Pub in 1982. (Raymond collection.)

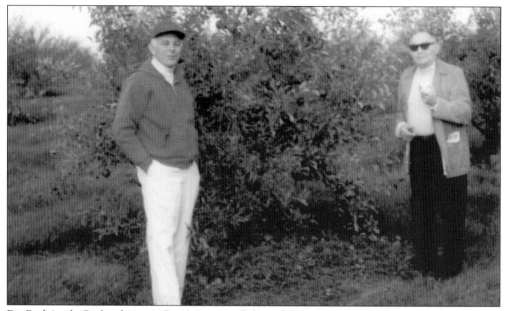

Big Red Apple Orchard owners Ben Mossman (left) and Sam Franco opened a new "pick-your-own" orchard that was a new trend in the orchard business. Ben Mossman was a co-owner of the Wrigley Supermarket chain and invested in orchards to supply the supermarkets. He owned orange groves in Florida and 12,000 acres of land in Romeo to grow apples. In 1973, Wrigley's introduced the Big Red chewing gum named after the orchard. The men are photographed here in the orchard in July 1971. (Miller collection.)

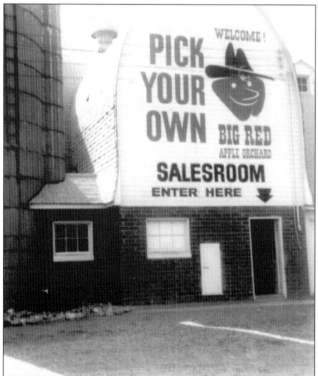

The Big Red barn located at 4900 32 Mile Road is shown here in October 1971. Years later, around 1984, Bernard and Jane Miller purchased the property and kept the pick-your-own theme and renamed it Miller's Big Red Apple Orchard. Brothers Ray and Ken Miller, the sons of Bernard, now operate the orchard, which is now down to 110 acres with rows of Jonathon, Red Delicious, and MacIntosh apples. It is still a popular orchard, as it now features a cider mill, fudge room, and a busy bakery for hot doughnuts. (Miller collection.)

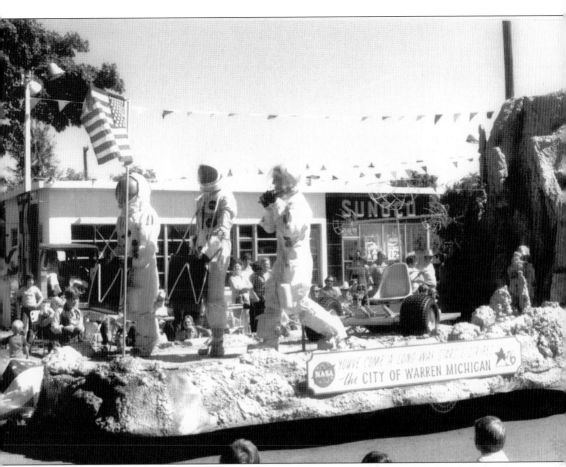

In 1976, America's bicentennial was celebrated and the Floral Parade was filled with floats that just had to have patriotic themes. The city of Warren entered an interesting float that year. The banner states, "You've come a long way stars and stripes," sort of a lunar experience with a fife and drum moon walk. The float is passing a Sunoco gas station at 209 South Main Street. (Havers collection.)

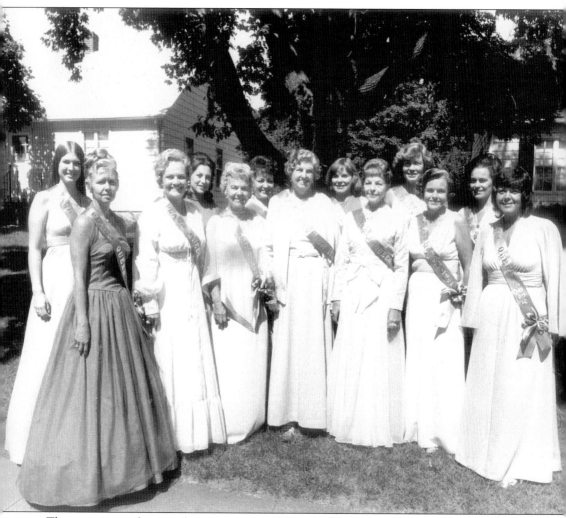

There was a peach queen homecoming in 1976, a brilliant idea of *Romeo Observer* editor Jim McPartlin with the help of a reunion committee. The women that returned for the weekend attended a queen's ball and the queen's coronation ceremony. Standing together before the parade are, from left to right, Susan Pill (1963), unidentified, Doris Sternberg (1946), Wallyene Ragel (1962), Ruth Sheardy (1934), Rosemary Murray (1950), Helen Cheesman (1932), unidentified, Lois Beal (1937), Karen Hoff (1954), Margaret Emery (1941), unidentified, and Nancy Seeman (1953). (Havers collection.)

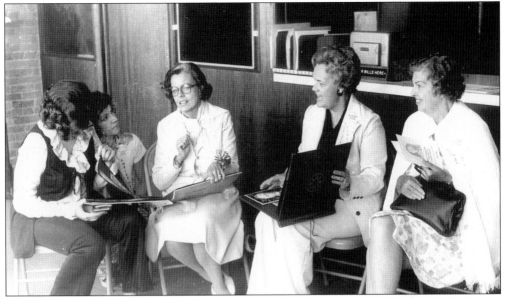

The homecoming celebration also included former Miss Romeos. At the Romeo Village Hall there was a registration and information center where contacts with others could be made. Some of the ladies took questions about their experiences and shared their photographs and scrapbooks. From left to right are unidentified, Shelia Dahn (Miss 1959), Margaret Emery (Queen 1941), Doris Sternberg (Queen 1946), and Helen Cheeseman (Queen 1932). (Havers collection.)

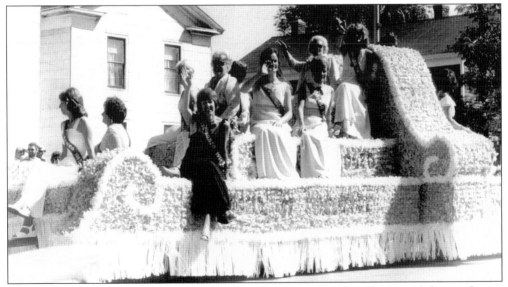

The former Miss Romeos appear on a float in the 1976 Floral Parade. From left to right are Virginia Verellen (1962), Shirley Wiers (1946), Pat Dallwitz (1955), Dolly Campbell (1936) in sunglasses, Annette Schueneman (1967), Velma Jean Schultz (1948), Mary Gilcher in sunglasses (1928), and Cynthia Geisler (1973), the last Miss Romeo. Mary Gilcher represented Romeo in a Miss Macomb County contest in 1928, when she was nicknamed "Miss Romeo" by the girls in her high school ukulele class. It was not until 1931 that the Miss Romeo pageants officially began. (Havers collection.)

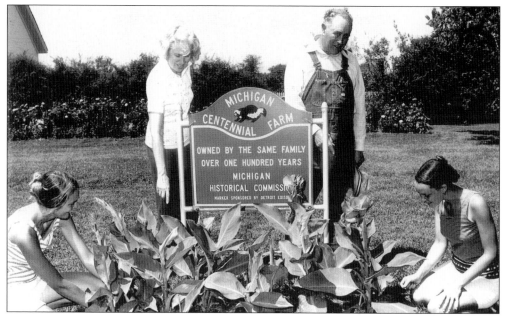

The Westview Orchard was recognized as a Michigan Centennial Farm by the Michigan Historic Commission in the mid-1950s. Upon Harvey Bowerman's death in 1971, siblings Katherine Roy and Armand Bowerman, representing the fifth generation of Bowermans, continued running the farm. By 1981, the orchard was operated by Katherine along with her daughters, Abigail and Katrina. In 1987, it was recognized by Michigan State University and Michigan Centennial Farm Association as being the oldest sesquicentennial family farm orchard in Michigan. From left to right are Abigail Roy, Katherine Roy, Armand Bowerman, and Katrina Roy. (Westview Orchard collection.)

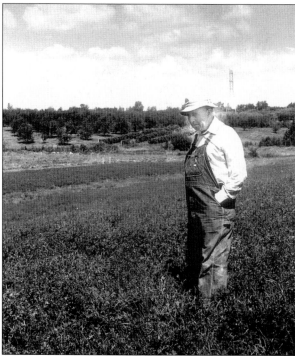

Armand Bowerman stands in the north hay field of Westview Orchards in 1976, the great-great-great grandson of Michael Bowerman, who was a lifelong resident and farmer. In the 1930s, Armand attended Hills Dale College on a baseball scholarship, and graduated with a bachelor of science degree in chemistry, the first in the Bowerman family to get a degree. Armand passed away in 1981, at the age of 71. (Westview Orchard collection.)

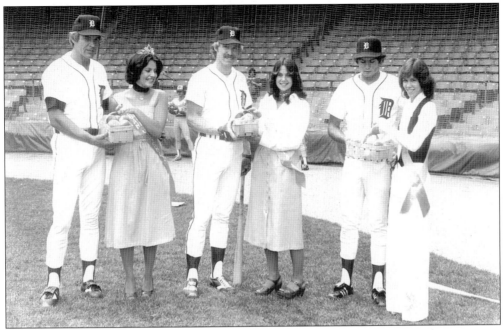

The 1978 peach queen, Diane Gola of Clinton Township, and her court caught a game at Detroit's Tiger stadium and presented members of the Detroit Tigers peaches from Verellen Orchard. From left to right are Mickey Stanley, queen Diane Gola, Steve Dillingham, Karil Zurakowski, Mark Wagner, and Cindy Hudson of Romeo. (Card collection.)

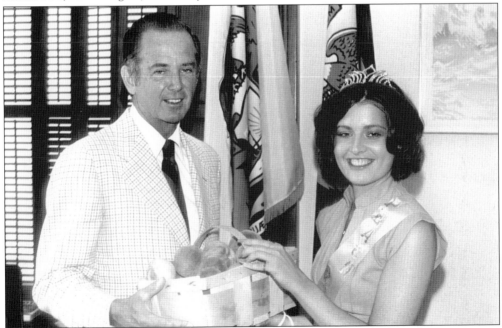

Peach queen Diane Gola presents a basket of peaches to Michigan governor William G. Milliken at the state capitol building in Lansing. The governor, who served in office from 1969 until 1982, was very supportive of the peach festival, walking in several parades and greeting the crowds. (Card collection.)

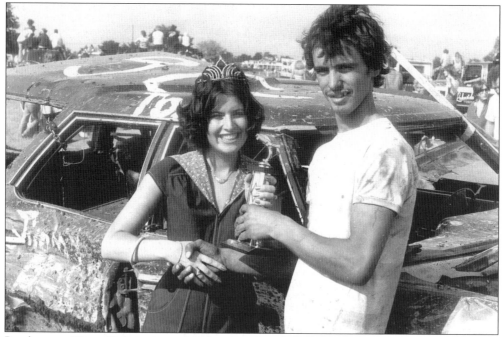

Peach queen Diane Gola is pictured with an unidentified winner of the 1978 Demolition Derby; the derby was held on the Esper property on 33 Mile Road between McKay and Powell Roads. The event included five elimination heats with a fight to the finish, the drivers battled their way to be the sole survivor and win the $500 prize and a trophy. (Card collection.)

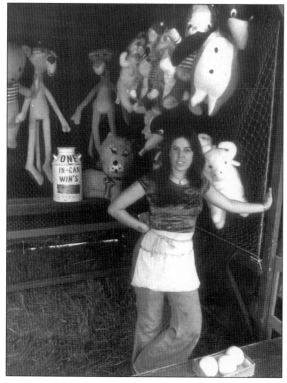

Step right up, get one baseball in the can. The winner gets a choice of the many oversized stuffed animals. The carnival was introduced to the festival in 1951, it was first set up on East St. Clair Street and the parking lot behind the northeast block of Main Street. In 1956, the carnival and the game tents were moved to the new Lions field. Wade Shows began setting up the carnival in the 1960s. For the last 20 years, Pugh Shows, which evolved into Mid America Shows has been entertaining the fearless riders to date. (Card collection.)

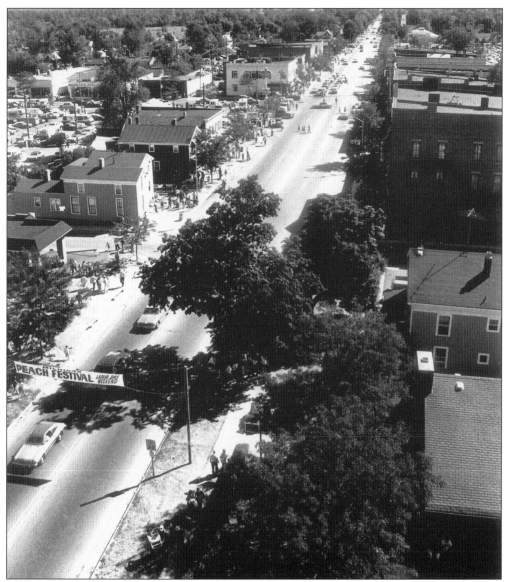

This 1978 photograph of downtown Romeo was taken from the steeple of the First Congregational Church. This view is looking south on Main Street sometime during the Labor Day weekend. Local photographer Doug Card, whose work appeared in the *Romeo Observer*, braved the tower of the church to get this shot; climbing three tall ladders, and going through two doors to get to the peak of the church's tower, where only a two-foot wall surrounds the top. (Card collection.)

The 1979 peach queen, Tammy DeBono of Roseville, was officially crowned at the queen's ball by Michigan State representative Ken DeBeaussaert. The event was held at the Club Orchard Hall on 31 Mile Road. During her reign, she was given a tour of the Ford Proving Grounds, the former Hi Point orchard property, and a meeting with Gov. William G. Milliken in Lansing. (Card collection.)

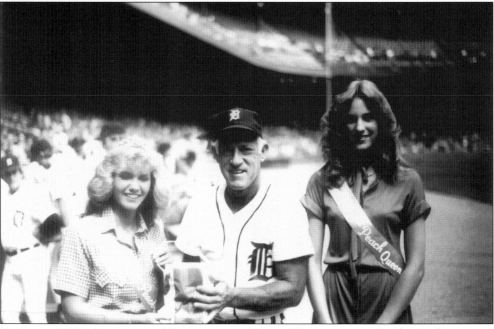

In August 1979, the queen and her court met Detroit Tiger manager Sparky Anderson and presented him with a sack of peaches before a game at Tiger Stadium in Detroit. From left to right are queen Tammy DeBano, Sparky Anderson, and Lisa Flannigan of Romeo, the first runner up. (Cox collection.)

Five

THE 1980S TO 2006

Ella Josephine Arnold performs in the Floral Parade around 1980. Growing up in Romeo, she worked at the D&C store, Sam's Shoes, and Chaptons clothing store. Arnold played piano for 96 years, performing for silent movies at the Almont Star Theatre and the Palace Theaters in Romeo and Pontiac. She played the calliope in the Floral Parade for a number of years. The calliope was an instrument that resembled an organ and consisted of a series of whistles sounded by compressed air. Arnold passed away at the age of 101 in June 1994. (Raymond collection.)

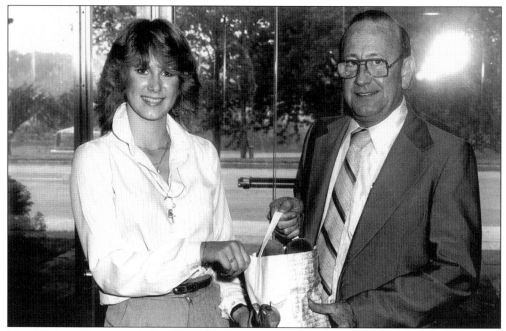

The 1980 peach queen, Robin Riss of Sterling Heights, presented J. L. Conrad, the manager of the Ford Proving Grounds, with a sack of peaches. The queen appeared on the John Kelly morning television show and presented peaches to Gov. William Milliken in Lansing, promoting the weekend festival. This year, the peach queen pageant was moved to the new Romeo High School auditorium. (Cox collection.)

These two clowns are clowning around near the corner of North Main and West Gates Streets. Joan Blue and Vera Brandt were members of the Methodist church. The parish had an active youth group, and joined in the fun in a mid-1980s parade. The gas station behind originally began as a Hi Speed Gas in the 1930s, and ended as a Boron station in 1985. (Brandt collection.)

The 1982 peach queen, Laura Amon, was the fourth girl from Romeo to become peach queen. The daughter of Bob and Judy Amon, Laura graduated from Romeo High School in 1981. As usual, the queen met with Gov. William G. Milliken in Lansing to deliver a basket of peaches. (Cox collection.)

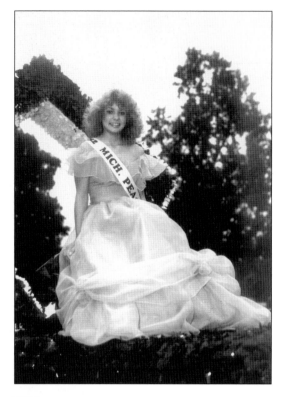

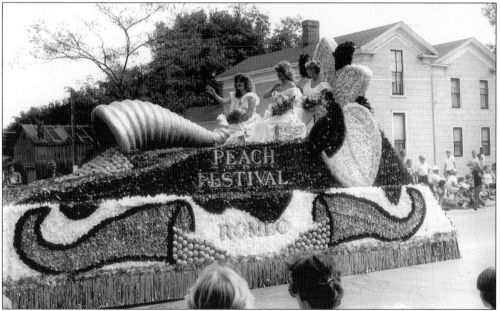

The 1983 peach queen, Kristine Beauchamp of Armada, and her court are riding on a new peach queen float. From left to right are Jody Paladino of Romeo, Stacy Fry of Dearborn, and queen Kristine Beauchamp. The float was constructed by float builder Larry Thompson of New Baltimore. The green and white with gold trim float featured a gold horn spilling peaches and is passing in front of 228 North Main Street at the corner of Newberry Street. (Cox collection.)

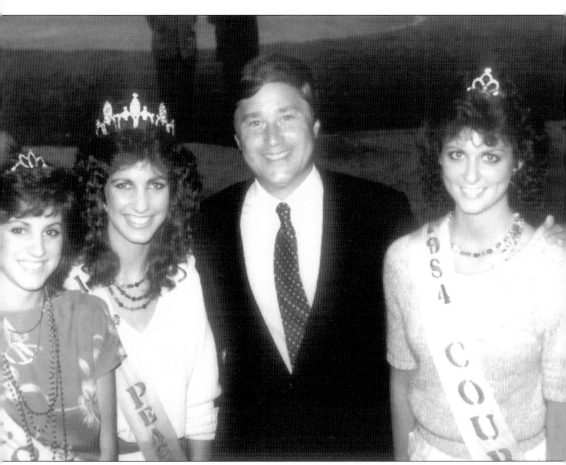

The 1984 peach queen, Lorry Purvin of Warren, and her court got the chance to meet Michigan governor James Blanchard while they were at Tiger stadium. From left to right are Tracy Stewart, queen Lorry Purvin, Gov. James Blanchard, and Marcia Verellen, the sister of Virginia Verellen, Miss Romeo of 1962. Governor Blanchard served in office from 1983 to 1990. (Cox collection.)

In 1984, peach queen Lorry Purvin and peach festival president Gordon Dorris pose together at the queen's ball. Dorris was the president of the Lions from 1983 to 1984 and president of the peach festival in 1984 and 1985. A member of the Romeo Lions since 1980, he wears his very own peach festival button on his sport coat. (Cox collection.)

The Scrambler was introduced as an amusement ride in 1955. Built by the Eli Bridge Company, it was known for its durability and its low maintenance, and it remained a favorite among carnival operators because of its popularity. In the early days of the carnival, it was safe with the merry-go-round, Ferris wheel, and the roller coaster. The invention of the Scrambler changed all of that, being the first of its kind to whip the passenger around in a circular frenzy. (Cox collection.)

In a mid-1980s Children's Parade, Brownie troops pass the Masonic temple building. The only Brownie identified is Jessica Dest, the young girl looking toward the camera in front of the Ice Cream Saloon. The saloon opened in 1976 and closed in 1999. In 2000, it was reopened as the Romeo Ice Cream Parlor and Country Store. To the left is Fettig's Keepsake Shoppe, with Rusty Fettig's photography studio on the second floor. (Stirling collection.)

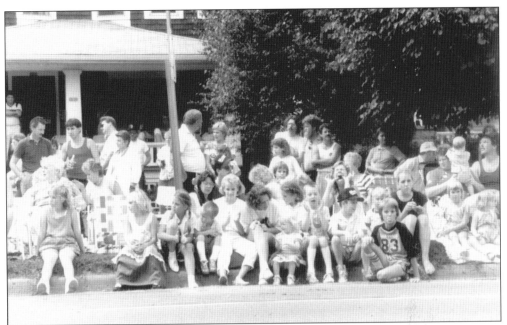

A crowd of people view the parade in front of 180 South Main Street in 1989. The Labor Day festival attendance has grown since it began. This year, the weather was perfect, and thousands of people attended the festival weekend. Also that year, *Romeo Observer* publisher Mel Bleich was the grand marshal of the Floral Parade. (McLaughlin collection.)

Brothers Eli and Adam Parks get a hearty laugh at the Floral Parade. The boys are watching the parade in the same group as shown above. The Floral Parade had over 120 entries and was at least three hours long. (Parks collection.)

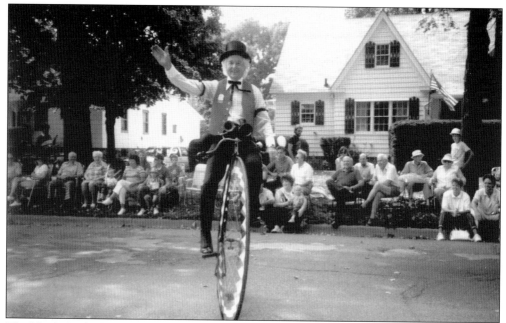

The Hardy Highwheelers were a novelty act that returned to the parade year after year. A father and daughters team drove the bicycles with the large wheel in the front and small wheel in the back. Here is Mr. Hardy himself on an 1885 Columbia, peddling in front of 365 North Main Street in 1987. It was some of these old-fashioned entries that give the parade its historic charm. (Vagi collection.)

At the carnival, Ian McLaughlin takes a spin in the helicopter ride. It is a sort of military exercise in endurance to pull the handle back and fourth to make the whirlybird go up and down. The helicopter rides began appearing at fairs in the 1950s and became one of the favorite amusement rides with the little kids. (McLaughlin collection.)

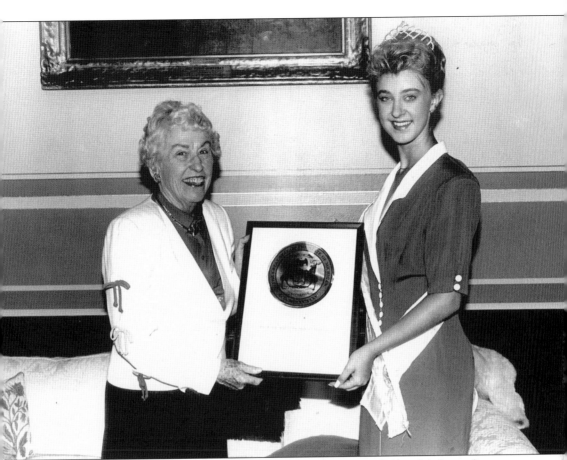

The 1990 peach queen, Jennifer Gondert of Romeo, receives a gift from Michigan lieutenant governor Martha Griffiths in Lansing. Gondert was the fifth girl from Romeo to win the title; she was a 1987 graduate of Romeo High School and the sister of Kathy Gondert, Miss Romeo of 1969. Martha Griffiths was the first woman elected to be Michigan lieutenant governor. Griffiths served two terms with Governor Blanchard, and was the grand marshal for the peach festival Floral Parade in 1986. (Gondert collection.)

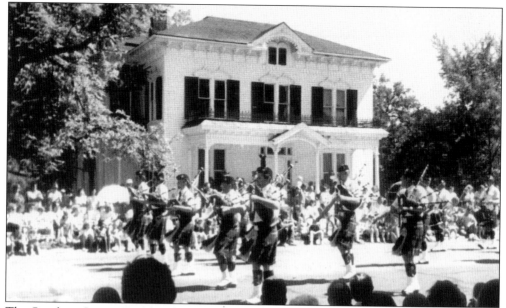

The Strathroy Legion Pipe band performs in the 1991 Floral Parade. One of several bag pipe groups, the band was formed in 1963 and has participated in pipe band competitions in Canada, Scotland, England, Northern Ireland, and the United States. At the moment, the bag pipers are passing 185 South Main Street, the George Washington Brabb house, which was built in 1877. (Raymond collection.)

In 1991, the peach queen was Ginger Besaparis of Grosse Isle. The queen and her court are meeting Katherine Roy, the grand marshal of the Floral Parade of 1991. From left to right are (first row) second runner up Amy Kittinger of Romeo and first runner up Lisa Saponaro of Shelby; (second row) queen Ginger Besaparis, Katherine Roy, Bob Hotchkiss, and Katrina Roy. The actual peach queen pageants ended in 1991. (Vagi collection.)

The 1994 peach queen, Michelle Perrini of Stirling Heights, meets Michigan governor John Engler at the staging area prior to the Floral Parade. The queen was crowned at the Lions Club, this time with an interview process before a panel of judges. The queen appeared at Richmond's Good Ole Days and the Armada Applefest. Gov. John Engler was in office from 1990 to 2002. (Vagi collection.)

Chandler Street neighbors Eric McLaughlin and Scott Kuebler enjoy the view of the parade with curb seats. Invited to a friend's yard party on North Main Street, they ended up with the best seats in the house. (McLaughlin collection.)

In the 1994 Mummer's Parade, Ray Nightingale and peach queen Michelle Perini dress as Major Nelson and Jeannie of the *I Dream of Jeannie* television series. Nightingale was the queen's driver and a member of the Romeo Lions. The Mummers Parade would have a name change in an attempt to appeal to a larger audience since it now followed the classic car cruise. The first name change was in 1998 billed as the Parade of Lights, and then in 1999 it was advertised as the Night Parade. (Vagi collection.)

In 1994, what began as an independent movie based on the superhero Sewerman later became a non-entry in the Night Parade. Friends Dave Deering and Ed Kern were shooting film footage of Derwood Dern and his mutant chickens taking over downtown Romeo using the parade crowd as the background extras. The film was shelved, but the march of the chickens continued as an underground cult in the true spirit of the Mummer's Parade. Former chickens included, from left to right, Jeff Risch, Ed Kern as Derwood Dern, David McLaughlin, and Ian McLaughlin. (McLaughlin collection.)

The Romeo Community Youth and Civic Center was constructed in 1958 and located at 461 Morton Street. This is where the pageants were held during the 1960s and into the 1970s. It was used for many events during the peach festival. In 1972, the building held the teen dance, the queen's ball, and the Country Cuzzin's Peach Pit Square Dance all in one weekend. The last few pageants were held at the high school auditorium that was built in 1977. This building was remodeled in 1996 to resemble a more modern vinyl-sided structure. The stage was dismantled in 1994. (McLaughlin collection.)

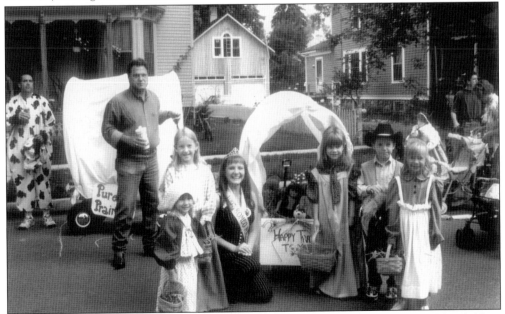

The 1997, peach queen Sherlynn Russell of Warren takes a moment to greet some of the children getting ready for the morning Children's Parade and is photographed in front of 119 and 125 East Hollister Street. From left to right are Jeff Clark, Matt Edwards, Chelsey Lerchen, Molly Edwards (in front), queen Sherlynn Russell, Jillian Clark, Sam Lerchen, and Kelly Edwards. The kids won first place in the small walking group category. (Vagi collection.)

The 1998 peach queen, Heather Hampton of Hazel Park, and her court members stand with the Hamilton Parsons first-grade Brownies prior to the Children's Parade. Identified here are Karly Wagner, Madison Goforth, Amy Dean, Gretchen Wilt, Jaclyn Bingham, queen Heather Hampton, Jennifer Secord of Romeo, Jacqueline Jacobs, Courtney White, Jessica Randall, and Melissa Dean. The girls are lined up on East Hollister Street. (Vagi collection.)

The queen also takes the time to pose with the young volunteers who are going to carry the Mainstreet Romeo banner in the parade. Photographed on West Hollister, from left to right, are Carolyn Obrecht, Eric Obrecht, queen Heather Hampton, Michelle Obrecht, and Malorie Obrecht. Mainstreet Romeo was a non-profit group, part of a national program that promoted historic areas. It was established in 1997 and disbanded in 2004. (Vagi collection.)

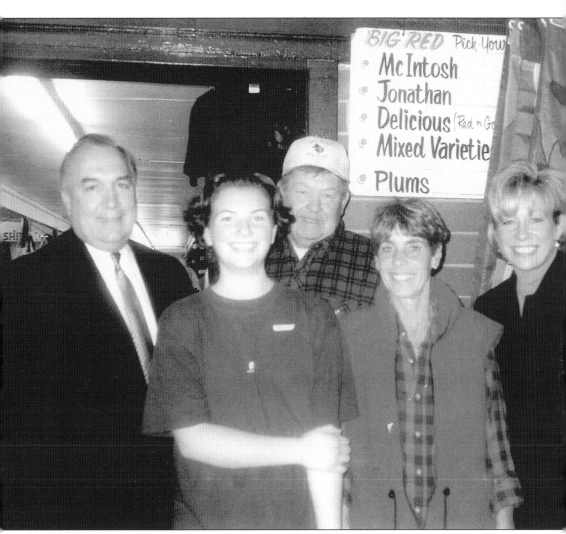

In 1998, Michigan governor John Engler made a visit to the Miller's Big Red Apple Orchard. The governor toured the orchard and was impressed with the delicious apples and cider. From left to right are Gov. John Engler, Kelly Miller, Bernard Miller, Gretchen Hough, and Mrs. John Engler. (Miller collection.)

The local award-winning community access station WBRW went on the air in the Romeo, Bruce, and Washington area in 1987. The new cable station near the former youth center was built in 1994. The station began taping the peach festival events in 1989 and eventually broadcasted the Labor Day parades live from 1990 to 2004. WBRW station manager Richard Cory and producer Jeannie Lerchen are commenting via the live feed from their platform near the center of town. (WBRW collection.)

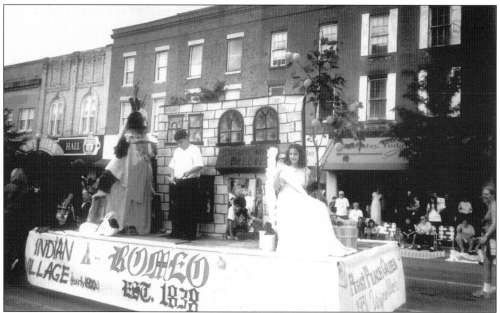

In 1997, there was a nod to Romeo's past with a float featuring a few of Romeo's own. From left to right are Megan Averitt as an early Romeo High School graduate, Robbie Dunlop as Clyde Craig the blacksmith, and Julia Young, portraying the first peach queen, Virginia Allor. Behind is the northwest block of Main Street, which has endured all of the parades and its spectators over the years. (Robinson collection.)

After the 2000 Floral Parade, Texas governor George W. Bush appeared in Romeo for a presidential campaign rally at the Mellen House located at 124 West Gates Street. After his lengthy speech on the front porch, he exited through the back fence into the Deerfield subdivision, meeting residents who were waiting to greet the candidate. From left to right are Gen Kasuri, Reggie Jose, Lynn Witt behind Kim Kasuri, and George W. Bush. Panting below with a strand of pearls is Bugsie. George W. Bush was later elected president of the United States the following November. (Kasuri collection.)

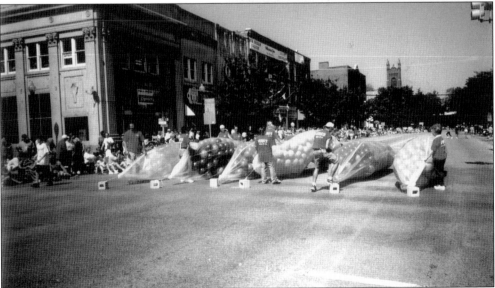

The official start of the 2001 Floral Parade was celebrated with a release of over 2,500 helium balloons. Vera's Balloon's R Fun and the Romeo Lions shared in the donation. Volunteers are holding one of six quick-release bags in place waiting for the signal. The balloon release originally began as a celebration for the new peach queen float in 1993 and then continued until 2002. (Brandt collection.)

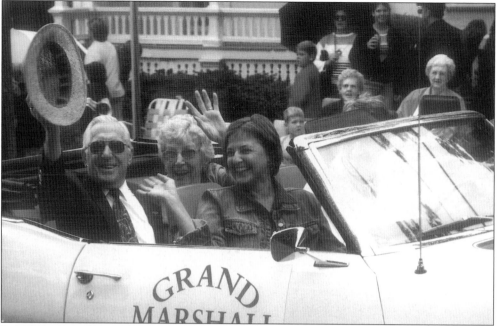

Bob Ebeling was honored as the 2003 grand marshal of the Floral Parade. Ebeling was a lifelong resident who grew up on the family farm on Ebeling Road, which was named for his grandfather. Traveling in style with family members are, from left to right, Bob Ebeling, Florence Ebeling, Lynda Ebeling, and in the driver seat Tom Ebeling. (Gawne collection.)

In 2003, two peach queens made a joint visit to the state capitol building in Lansing. From left to right are Michigan governor Jennifer Granholm, 2003 queen Kimberly Lavely of Richmond, 2002 queen Ashleigh Beadle of Romeo, and Michigan state representative Brian Palmer. Governor Granholm entered office in 2003. (Vagi collection.)

In the 2003 Floral Parade, the Reverend Peter Vos portrayed the First Congregational Church founder Rev. Issac Ruggles, who was born in 1783 and died in 1857. Ruggles organized many Congregational churches, one located in the village of Romeo. The Reverend Peter Vos served the First Congregational Church of Romeo from 1954 to 1977. Seated beside him is Helen Miller, who has been a member of the church since the 1950s. To the right is Tessa Willenborg. (Willenborg collection.)

In 1938, Henry and Lena Verellen purchased 10 acres of land from his brother Ed Verellen, and called it Juliet Orchards. In the 1950s, their son Robert Verellen took over the orchard and renamed it Verellen's Orchard. In the 1980s, Robert's son William Verellen began operating the orchard, calling it the Verellen Orchards and Cider Mill, photographed here in the spring of 2005. (Verellen collection.)

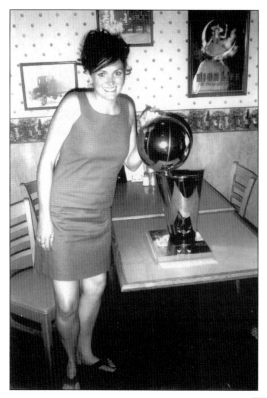

In 2004, the Larry O'Brien trophy, more commonly known as the NBA Championship trophy, made a special appearance at the Night Parade. It was won by the Detroit Pistons in June 2004. Romeo fan Lalanya Gawne stands next to the trophy that was carried through the Main Street Bar and Grill at 223 North Main Street after the parade. (Stefanski collection.)

Based on a 1959 magazine article on "bygone inventions at the turn of the century," the 1890 Swing Bike was completed in 1990 at Kriewall Enterprises east of the village. It was designed by Edwin Kriewall and Bob Lewis, friends who lived their dream to construct a one-of-a-kind means of transportation. The two-wheeled bike has driven 2,000 miles and has appeared in over 100 parades, including the Floral Parade shown here in 2005. From left to right are Laura Nimbach, village clerk Marian McLaughlin, and Edwin Kriewall. (Willenborg collection.)

The new peach queen float is parked in front of the former La Juliette Motel in 2005. The floats started to fade out during the late 1960s. In 2005, Lion's member Ray Nightingale, with the help of other volunteers, built an all-new wood float for the peach queen. Over the years, the number of floats has dwindled to less then 20 in a parade of roughly 130 entries. (Vagi collection.)

A new generation of children enjoys the 2005 peach festival. Together Josh Vagi and his son Owen are enjoying the Rainbow Slide at the carnival. (Vagi collection.)

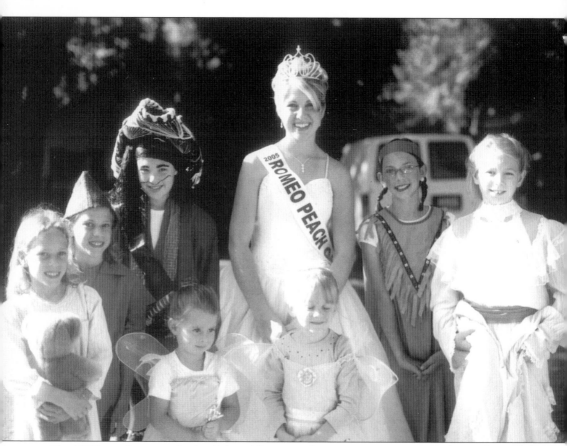

The 2005 peach queen, Jessica Foltz of Romeo, takes a moment to pose with members of the Children's Parade on Labor Day morning. Jessica, the daughter of Jeff and Pat Foltz, graduated from Romeo High School in 2003. In April, the queen was given the title at the Washington Township Municipal Building in front of a panel of judges. The second runner up was Breanne Fiebelkorn from Sterling Heights. Flotz won for her maturity and ambition. The children, dressed as characters from Peter Pan, include, from left to right, Kerri Ann O'Connor, Jamie O'Connor, Ryan Ferguson, Marisa Averitt, queen Jessica Foltz, Laney Robinson, Casey O'Connor, and Tessa Willenborg. (Willenborg collection.)